drawing the human body

Improve Your Painting and Drawing

Fountain Art Series. Fountain Press London

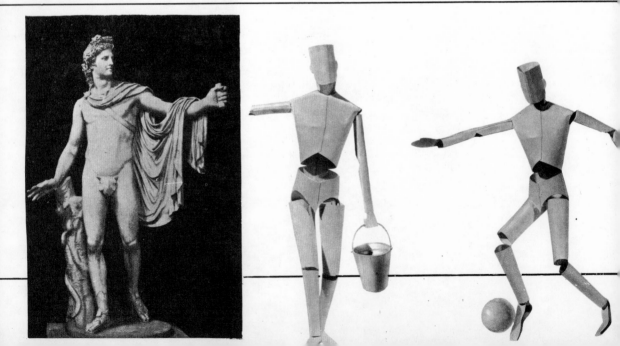

J. M. Parramon

drawing the human body

173

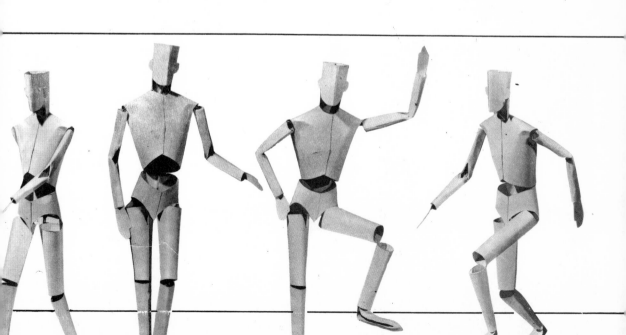

Fountain Press
Model & Allied Publications Ltd.
Station Road,
Kings Langley,
Hertfordshire,
England

First Edition in English, 1973
Original title in Spanish
«Cómo dibujar la figura humana»
© J. M. Parramón

ISBN 0 852 42101 X

Printed in Spain by
Industrias Gráficas Miralles, Torns, 2. Barcelona-14
Depósito Legal: B-50.023-1972.
Número Registro Editorial: 785

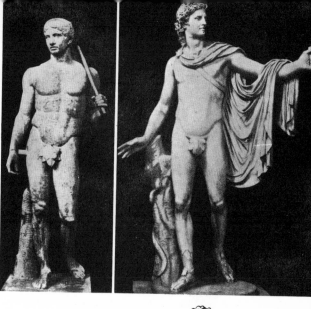

Study of proportions

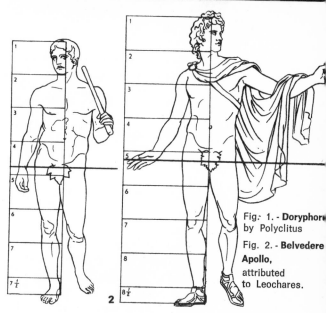

Fig. 1. - **Doryphor**
by Polyclitus

Fig. 2. - **Belvedere
Apollo,**
attributed
to Leochares.

Polyclitus, Praxiteles and Leochares. All three were famous sculptors in ancient Greece and all three were concerned with a question which was not finally settled until the early 1900s. It was this: what are the ideal proportions for the human figure?

Briefly, the story goes like this:

In the 5th century BC —some 2,500 years ago— Polyclitus wrote a treatise which he called *The Canon*. In this treatise he formulated the following rule: *To get various parts of the body perfectly proportioned in relation to each other and the whole, the height of the figure should*

(1) By CANON we mean *the rule or system which, using one basic measurement, determines the proportions of the human figure.* We call our basic measurement a MODULE. Since the Renaissance, the module has been taken as a head-height. In Polyclitus' Canon, he used as his module the breadth of the palm. For the sake of simplicity we have changed it and made it the same as ours. The result is identical —it does not affect the Greek canon— but it makes for easier comparison with modern canons.

be 7¹/₂ times the depth of the head. (1) Practising what he preached, Polyclitus applied this rule in all his own sculptures (fig. 1).

Polyclitus' Canon was accepted without question by all his contemporaries, among them Phidias and Myron, becoming a landmark in the history of Greek art and establishing the style and proportions of the so-called *Classical period*. It might have been reasonable to assume that henceforth all artists, draughtsmen, painters and sculptors would have used this 7¹/₂ module canon to achieve a perfectly proportioned human figure. However...

Not a century had gone by when a new prodigy, Praxiteles, formulated an 8-head canon. And, at almost the same time, another famous sculptor, Leochares, produced the celebrated *Belvedere Apollo*, one of the most beautiful statues in the world, based on an 8¹/₂-module canon (fig. 2).

Which of the three was right? Which canon should future artists accept?

Clearly, Renaissance painters and sculptors —2,000 years after Polyclitus— asked themselves the same questions. It's plain that no satisfactory conclusion was reached.

Seven-and-a half! said Michelangelo, when he created his famous statue *David*.

Eight! asserted Leonardo da Vinci, producing a canon of his own.

Eight-and-a-half! contradicted Michelangelo, who never took kindly to rules and regulations, this time presenting the set of drawings in the Albertina collection.

Nine! cried Botticelli, flourishing his *St Sebastian*.

... ...

ELEVEN! thundered El Greco some years later, painting his weird, elongated figures.

In 1870, the Belgian anthropologist Quételet decided to get to the bottom of the matter and put an end to the controversy once and for all. He picked 30 people of different shapes and sizes, compared their measurements and proportions and found a norm which satisfied him. The result was a 7¹/₂-module canon, an 'ideal' figure very similar to the *Doryphorus*.

So Polyclitus was right after all!

... ...

'Wait a minute! said Stratz, another scientist, in the early 1900s. 'Polyclitus was right... *if* we're talking about the proportions of the plain, ordinary man, the man in the street — a type which, simply because it is average, cannot be the ideal'.

In other words, Stratz declared that, to find the 'ideal' type, *one must start off with a pre-selected set of people*. So he picked a group of people who were all tall, athletic and well-proportioned and found an average, getting in this way a truly ideal figure: a man whose proportions fitted an 8-module canon.

Finally, using the findings of Ritcher, Von Langer and Stratz himself, we can see that the *Belvedere Apollo* with its 8¹/₂-module canon is an exaggeration of this 'ideal' figure. We get a picture of a huge man of

Three canons for the human figure

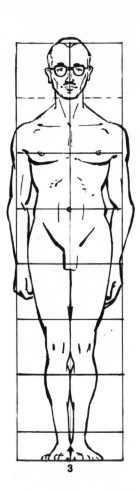

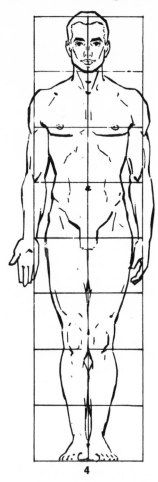

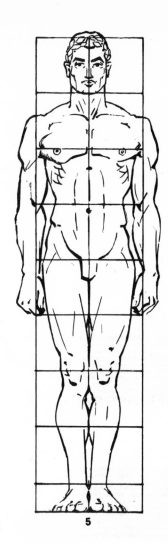

3

4

5

heroic proportions, larger than life. Leochares, creator of the Belvedere Apollo, almost certainly used this canon intentionally, seeing in his mind's eye that this wonderful unreality would be the best way to depict one of the Gods of the Arts in Ancient Greece.

So the problem was settled. Thanks to our predecessors we can know and accept that:

1. — There are three canons which can be used to get the correct proportions of the human figure:

 a) A 7½-module canon for the normal figure (Fig. 3);

 b) An 8-module canon for the 'ideal' figure (Fig. 4);

 c) An 8½-module canon for the heroic figure (Fig. 5).

2. — Artists usually use the 8-module canon, the one for the 'ideal' figure (Fig. 4).

Let's consider what all this means in practical terms:

The 7$\frac{1}{2}$-module canon can be used for drawing ordinary, run-of-the-mill people — the anonymous figure of your next-door neighbour, the local shop-keeper. the man in the street. He'll be of medium height, some 5'9" or so, fairly thickset, with a rather large head slightly out of proportion to the rest of the body, muscles and limbs (as in fig. 3).

The 8-module canon gives you the proportion of the 'ideal' figure: a slim, athletic type, above average height — about 6'0". His head. body and limbs are all in perfect proportion. This too could be a man in the street, but it would be someone rather out of the ordinary. It is this figure which we shall use for our study of the proportion and construction of the human figure (fig. 4).

The 8$\frac{1}{2}$-module canon — up to 9 modules if needs be — will be the one you want in a few unusual cases. You can use it for heroic, legendary, glamourised figures. Fiction illustrators generally take this type — the head small in relation to the body, long arms and legs, etc. It's the hero figure — Superman or the Lone Ranger, perhaps! And it could also be used for a biblical figure like Moses, a legendary figure like El Cid and in pictures with a religious or historical theme (fig. 5).

Let's move on now and examine the 'ideal' 8-module figure, basing this on our knowledge of the proportions and size of the human frame. Study the next bit carefully because this, plus a knowledge of anatomy, is vital to the mastery of figure drawing.

THE 'IDEAL' MALE FIGURE

In figs. 6, 7 and 8 (facing page) we have the front, side and back view of the standing male figure, *proportioned according to the 8-module canon.*

First of all, note the overall proportions in the front view, comparing the height with the breadth. The figure is:

8 modules high
by 2 modules wide

so that, if we draw a rectangle 8 modules high by 2 wide, we'll get the box which encloses an ideally proportioned human body.

Now look even more carefully at the following basic parts of the body, which can be positioned automatically, using the dividing lines or modules of the canon. (The modules are numbered from 1 to 8 for ease of reference.)

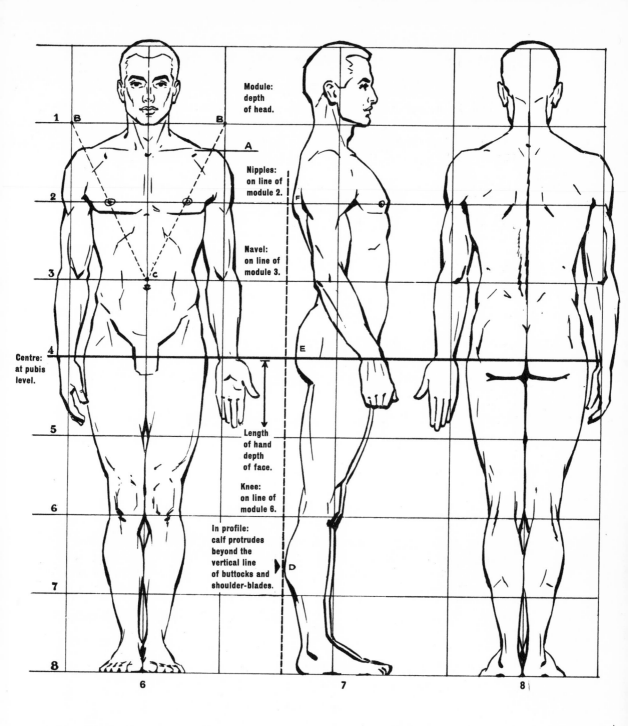

Module:
depth
of head.

Nipples:
on line of
module 2.

Navel:
on line of
module 3.

Centre:
at pubis
level.

Length
of hand
depth
of face.

Knee:
on line of
module 6.

In profile:
calf protrudes
beyond the
vertical line
of buttocks and
shoulder-blades.

a) *The level of the shoulders is at subdivision A, one third of the way down module 2.*

b) *The nipples are precisely on the line of module 2.*

c) *The navel is a little below the line of module 3.*

d) *The elbows are more or less at waist-level, just above the navel.*

e) The pubis is *on the line of module 4,* in the exact centre of the body.

f) *The wrists are on the same level as the pubis.*

g) *The extended hand is the same length as the face.*

h) *The total length of the arm — point of shoulder to finger tip spans 3¹/₂ modules.*

i) *The kneecap, or most prominent part of the knee (see fig. 7), is just above the line of module 6.*

Note the following principles which are equally vital in getting the construction and proportions of the male figure right:

1. — *Space between nipples = one module.*

2. — *Joining points B to point C by oblique lines (see fig. 6) gives us:*
 a) *the position of the nipples;*
 b) *the position of the tip of the clavicle — the most prominent point of the shoulder.*

Finally, examination of the male figure in profile (fig. 7) shows that: *the calf protrudes beyond the vertical line of the buttocks and shoulder-blade (points D, E and F).*

These points must be committed to memory if you are to be able to draw the male figure correctly.

THE 'IDEAL' FEMALE FIGURE

The canon of the female figure is again 8-module (see figs. 10 and 11 opposite). But, since the female head is proportionately smaller than the male, the overall height of the female figure is less than the male (about 4" shorter).

Let's establish the following ways in which the female figure differs from the male (compare figs. 10 and 11 with fig. 9):

a) *the shoulders are proportionately narrower;*

b) *the breasts and nipples are slightly lower;*

c) *the waist is somewhat narrower;*

d) *the navel is slightly lower;*

e) *the hips are relatively broader;*

f) *in profile, the buttocks protrude beyond the vertical line of the shoulder-blade and calf.*

That's the 'ideal' female figure... as long as fashions don't decree otherwise. Yes, one really must take fashion into account. At

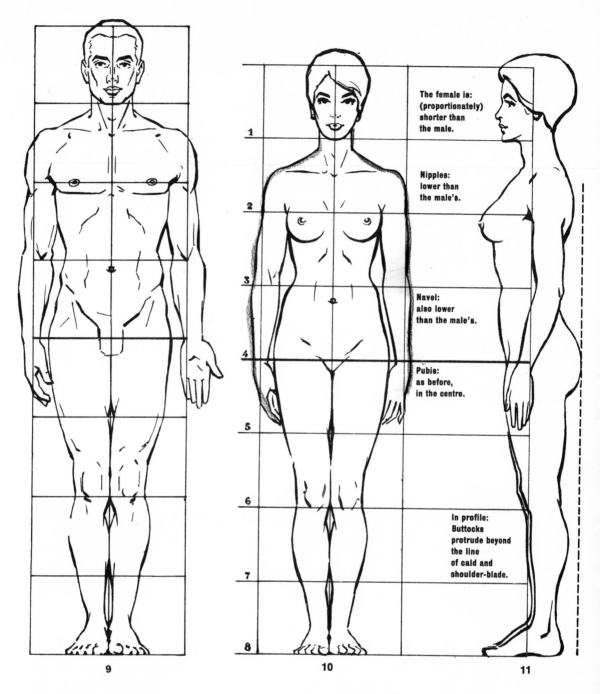

The female is:
(proportionately)
shorter than
the male.

Nipples:
lower than
the male's.

Navel:
also lower
than the male's.

Pubis:
as before,
in the centre.

In profile:
Buttocks
protrude beyond
the line
of cald and
shoulder-blade.

9 10 11

the turn of the century, for example, the 'ideal' female shape was something quite different. It was the time of the wasp waist, enforced by whalebone girdles and corsets with the resultant squeezing of the body leading to an overflow of bust and hips (hips really *were* broader then!). There was also a much greater behaviour distinction between the sexes. The woman (who was considered a delicate hot-house flower), played no sports, did little work, took practically no exercise and certainly wouldn't have held a record for the 100 metre crawl.

13

Nor would you find her teaching mountaineering or working as an engineer. It takes a while to realize that our modern way of life has brought changes in physique. Sport, fresh air and exercise, tough athletics and so on have produced a greater chest expansion as well as a general fining down of the female figure, which has undergone slight changes. The shoulders are less narrow, the profile trimmer and the lines of the body longer and slimmer than those of yesterday's woman. (Figs. 12 and 13 above illustrate these changes.)

So: the female figure shown in the 8-module canon (p. 13) is the classic type. She's neither a Dolly Dimples of the circus tent nor an attenuated Twiggy. And whatever our personal preferences may be, when we draw the female figure we must be careful to draw the woman of the Seventies — and not lay ourselves open to the charge of being behind the times. This is particularly important if we are drawing for commercial art.

INFANCY AND ADOLESCENCE

Big-headed, pot-bellied and short-legged — and adorable all the same! The baby is a real caricature of the ideal proportions mapped out by Polyclitus & Co. As any parent will know, from birth to manhood, the build of the growing child is constantly changing. These differences in proportion at different stages of childhood have physiological origins: the various limbs and organs of the body have different functions at different ages. The head is a good example of this — its development is proportionately faster because it has to function in an adult fashion almost from the start.

There's nothing for it but to learn at least four different canons, in which we'll round up the special characteristics of the various stages: the young baby, the two-year-old, the six-year-old and the 12-year-old. Fig. 14 opposite illustrates these four canons, with the canon of the 25-year-old male for comparison.

Note the following points against the relevant canon:

INFANT CANON: The height = four modules, so, comparing it with the adult, we can say that the head is twice as large in proportion to the body. The proportion of the trunk and arms is similar to that of the

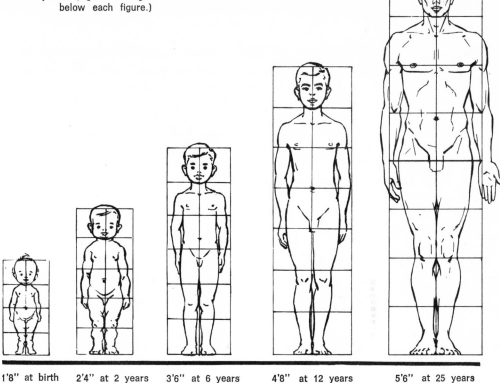

Fig. 14. — Comparison of the adult canon against canons for children from birth to twelve years. (Age and height are shown below each figure.)

| 1'8" at birth | 2'4" at 2 years | 3'6" at 6 years | 4'8" at 12 years | 5'6" at 25 years |

adult, but the baby's legs are proportionately much shorter. Notice that he has no waistline, but a large stomach and narrow thorax. Arms and legs are plump and chubby, with deep folds of flesh at the joints and virtually no sign of muscle.

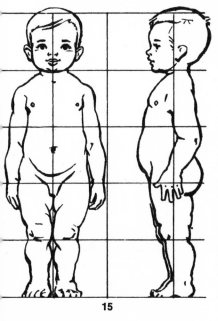

TWO-YEAR-OLD CANON: The two-yeard-old's proportions are similar to the baby's. His head is still large for his size; he has a shock of hair, wider-open eyes, chubbier cheeks and legs relatively just as short as they were. But the broadening of the thorax has begun, growing larger — not much larger, as yet — in relation to the hips and buttocks which are still relatively the largest parts of the body; the stomach is also large in proportion. This is the typical infant figure which Murillo used for his cherubs — and which the modern commercial artist uses to advertise baby powder. (With apologies to Murillo for mentioning his heavenly cherubs in the same breath as a remedy for chafing and nappy rash!) (Fig. 15).

15

SIX-YEAR-OLD CANON: Now the body is growing faster than the head. The height is already six modules. The trunk expands, gradually approaching adult proportions. The breast and nipples are almost in their adult position and the waist is beginning to narrow.

12-YEAR-OLD CANON: The height is now seven modules and the shape and proportions of the body have become still more adult. Look at fig. 14 carefully — you'll notice the similarity of the lines of the two largest canons. particularly the positioning of the pubis, the navel and the nipples. There's still a marked disproportion (compared with the adult) between the thorax and the pelvis. The development of the chest has caught up with the hips. But the legs are still relatively short, making the trunk long in proportion to the rest of the body. Plumpness has disappeared, but the muscles are not yet noticeable and the general impression is somewhat girlish.

FIGURE PROPORTIONS IN SEATED, KNEELING AND BENDING POSITIONS

To round off this section and give you a bit of extra help, we'll illustrate the figure proportions in some of the most usual postures: sitting on a chair, sitting on the floor, kneeling upright, bending down and so on. Fig. 16 below shows the figure in these postures against six guide or module lines, so that you can see that the height of the figure seated on the chair = six modules, on the floor = four modules, kneeling uprigth = six modules, and so on.

In principle, working from the standard canons (figs. 6-11), you ought now to be able to draw correctly proportioned figures in any posture. These canons tell you everything you need to know about proportions. Study them carefully and then practise drawing them yourself. That's all there is to it.

Well, no... not quite all. Just bear with me until the end of the next section.

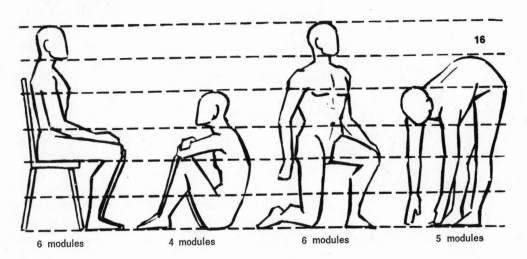

16

6 modules 4 modules 6 modules 5 modules

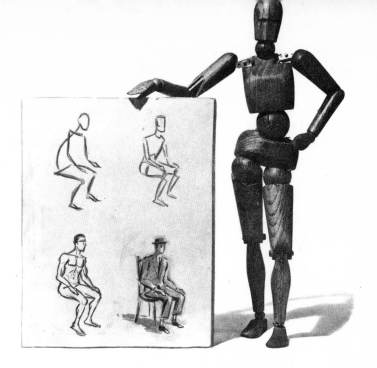

Construction of the human figure

In this section we come to something which every amateur draughtsman has attempted at some point and which very few have completely mastered: *figure drawing from memory.*

I must emphasise how vital it is for you to study and work at these exercises, although I realize you may be asking yourself what's the point in learning to draw from memory when you can use a model and draw from life. Well, in the first place, if you know how to draw the figure from memory, you'll find it very much easier to draw from life. The artist's ability to draw a figure from memory goes hand in hand with a facility to grasp and unravel the technicalities of anatomy and the proportions and basic construction of the model. Apart from this, there are many subjects which necessarily involve drawing or painting figures from memory. Take, for example, subjects like landscapes, seascapes, little huddled clusters of cottages or alleyways in a town or village which really cry out for a few figures dotted around. These figures can be small, of course, but they must still be drawn correctly as living, breathing people, chatting or going about their business. This situation often crops up when drawing from life is inconvenient — the model isn't around any more, or doesn't want to hang about while you get on with the picture. The secret is to have a brief but careful look at the pose and then work from memory. Also, bear in mind that by using your memory in this way you'll be really getting down to bedrock — sorting out for yourself *all kinds of problems* which arise in all kinds of subjects.

So let's suppose that your approach to art and to this book is not

purely art for art's sake, but that you're aiming at a career in commercial art, for example. It's a statement of the obvious that your future as a professional illustrator, as someone employed in the creative department of an advertising agency, as a magazine artist or in any other branch of commercial art (not to mention your salary in this field) will depend largely on how well you can draw the human figure from memory. Mastery of this is absolutely vital if you are to carry out what is required by your client or your boss — in other words, if you are to do your job adequately.

So I reiterate the importance of approaching this section as if it were part of your professional training. It should give you a really thorough grounding in figure drawing, for whatever purpose you need it and whether you'll be working with or without a model.

START BY GETTING DOWN TO BASICS

NOTE: In this section we start to make use of the knowledge we've acquired so far. We've reached the stage where we begin to put theory into practice, applying what we've learnt about the ideal proportions of the human figure. We must approach the exercises which follow in the most practical way possible by drawing and practising in order to get right to the bottom of the problem. So take your pencil and paper and have a go at mastering one of the most tricky — and most fascinating — bits of your artistic training.

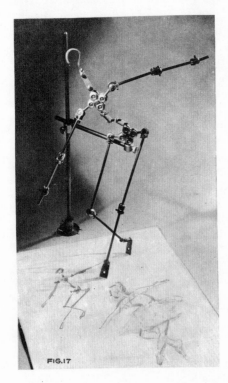
FIG.17

Some art shops sell a gadget for figure drawing — a kind of wire puppet like the one in fig. 17 (left). All the parts, including the head and torso, are merely pieces of wire fixed together by little joint-like hinges. It's not a new idea — before this particular gadget came on the market, various methods of figure drawing were taught involving the use of similar basic figure puppets.

I personally feel that such a complete synthesis of the human figure doesn't serve the purpose as well as a diagram. 'I don't possess one — they seem to be going out of circulation now.' 'There's hardly any demand for them' said a man in one art shop, ruefully, 'they seem too arbstract... not practical enough.'. Their practical value is certainly limited, but I believe something of the sort would be helpful to us in our study of theory and the examination of detail.

Where this kind of wire skeleton comes in very handy is in reminding us of two fundamental points which are vital when drawing figures from memory:

One expert in these matters has said: 'When drawing from life, you should work from the outside inwards; when drawing from memory,

1. — We must start with some knowledge of the human skeleton.

2. — Figure construction must be based on the symmetry of the body, which stems from its central axis OR SYMMETRICAL CENTRE.

build up from the inside outwards'. In other words, when we have our model before us, we should begin with a basic outline, adding details until we achieve the cmpleted shape, 'having worked from the outside inwards'. But, *when drawing from memory, we should start with the inner framework of the body — the skeleton — clothing it with flesh later, then drawing in the head and moving on to the externals, the completed drawing, 'having worked from the inside outwards'.*

The wire puppet serves to remind us that the body's structure and posture is based on a few basic skeletal lines. It's also helpful in showing us how the bones below the flesh influence the outward appearance. (figure 18 below illustrates this more clearly.)

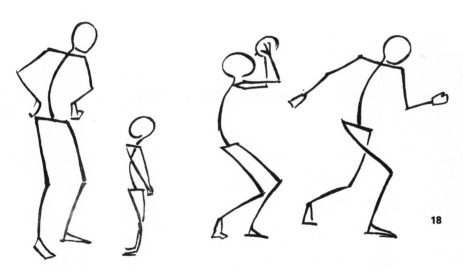

18

Also, the wire puppet, with its thin trunk, reminds us that

the human body is symmetrical

19

You know that the human body, seen either in front view or back view, has two similar sides stemming symmetrically from a central axis — two shoulders, two arms, two legs and so on. To sum up:

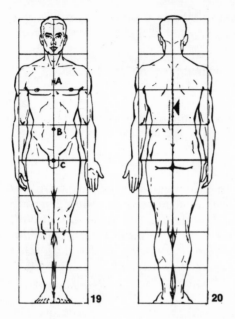

the symmetrical centre of the human body is marked in front by the line between the breasts, the navel and the pubis (Fig. 19, points A, B and C) and, at the back, by the ridge of the spinal column (Fig. 20).

Let's try to turn our wire puppet into something a bit more lifelike.

THE HUMAN FIGURE: PLAN 1

We'll start out with an ideally proportioned figure with solid head, thorax and pelvis, but with arms and legs in their skeletal bony state (fig. 21).

We'll examine the basic sections one at a time and draw them:

HEAD. — Shaped like a real head, but without the jutting nose, the eyes, mouth or hair — just the basic shape.

THORAX. — This is the most complicated section and I've tried to simplify it by using a set of geometric planes, as shown in fig. 22. Even so, you'll need to make several experiments. Please practise drawing it in different positions, as in fig. 22.

PELVIS. — It's easier if we think about this as the hips and buttocks. The shape is that of a pair of swimming trunks. Try to imagine them hanging on a line, filled out by the breeeze. If you copy the sketches the shape should become clear to you, especially the foreshortening which shows the cavities which would contain the thighs. Notice that the shape of the pelvis looks different in different positions and according to the artist's angle of vision (fig. 23).

ARMS AND LEGS. — These can be reproduced by single wires representing the various bones. Fig. 21 illustrates the connection of the femur with the

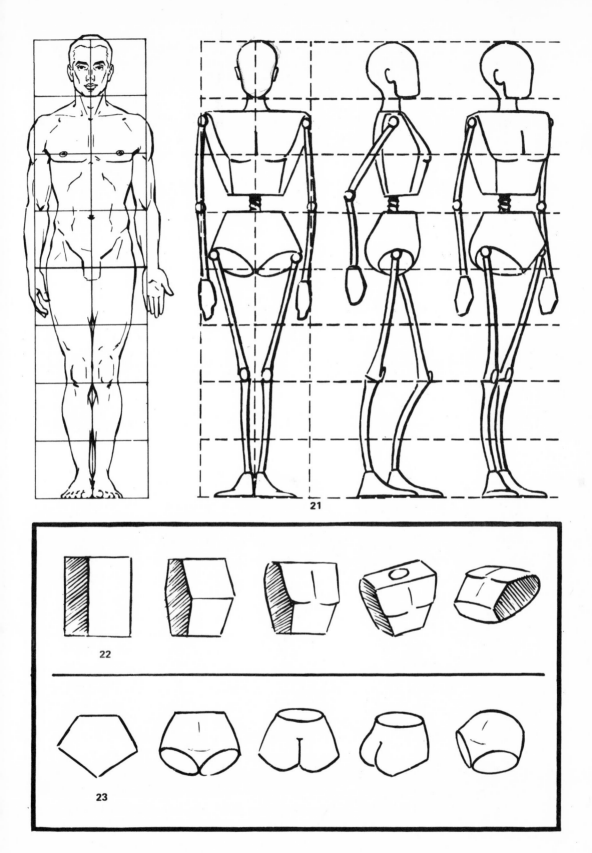

21

22

23

knee. The femur begins at the hips, where the protuberance of the tro-chanter major is apparent, as in a real skeleton. Note in the profile dia-gram (fig. 21 again) the forward curve of the femur and the backward curve of the tibia — the former because this is how it really looks and and also to give us a better impression of the muscular external shape, the latter to give us a clearer idea of the curve of the back of the calf and the forward line of the knee. Bear all this in mind when you draw these bones. The result may not be terribly realistic, but it will certainly be expressive.

HANDS AND FEET. — We'll leave these for the time being as shown in fig. 21.

Once you've made a careful study of these parts of the body, begin putting them together into a complete, standing figure as shown in fig. 24 below.

**Draw the figures in Fig. 24 below — and those that
follow — about 5" high .**

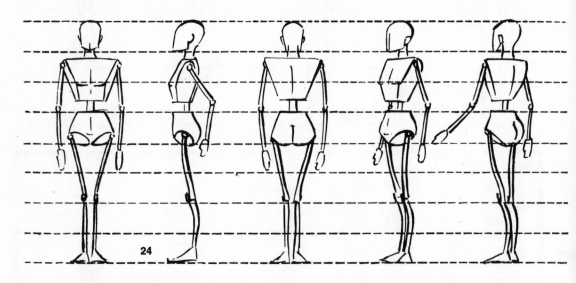

24

These drawings should be made in correct proportion; the best method of doing this is to make a faint modular grid with the eight equal divisions used earlier, as shown above. When you've done this, we'll take it that you are familiar with Plan 1, the standing figure drawn *from memory*. The next step is to get it moving — to breathe some life into it.

ISCHIATIC OR HIP POSITION

Another factor comes into play when the body makes certain move-ments such as shifting the weight from one leg to another, walking, running and so on. The ability to construct the human figure properly

22

depends to a great extent on a sound understanding of the ischiatic position or, in lay terms, the position of the lower bones of the hips. The technical name for these 'seat bones' is the *ischia*, and the term *ischiatic position* is descriptive of the way they tilt to one side or the other, depending on the movement or position of the body as a whole. This is also called the *hip position* — it's a general movement of the whole pelvis and hip area.

Significance of the hip position:

The hip position governs the angle not only of the pelvis, but also of the thorax — for instance, when the weight is supported on one leg only (fig. 25).

Let's look at the skeleton for a moment. Fig. 26 below shows a skeleton in standing position with the weight taken equally on each leg. In the lower centre part of the *pelvis* you can see the two ischia — in this case, absolutely horizontal. Fig. 27 shows two skeletons in positions of

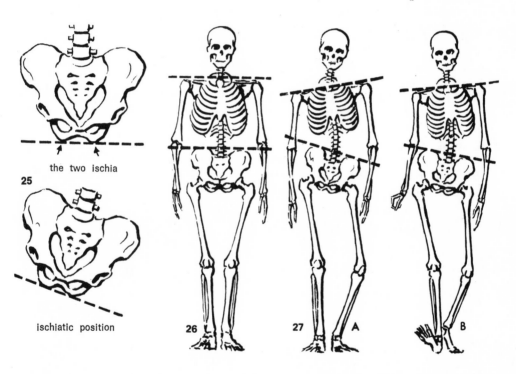

the two ischia

25

ischiatic position

26 27 A B

motion: skeleton A in a relaxed standing position and skeleton B in the act of walking. In each case all the weight is carried by one leg. In skeleton A, the other, resting leg is relaxed, and in skeleton B it is in the process of making a forward movement. *The tilt of the ischia* is significant in both cases and is consequential upon all or part of the weight being taken on one leg. But this isn't all; the tilting of *the pelvis* necessitates a tilting of the *thorax* in the opposite direction, as illustrated in figs. 27 A and B.

23

It's worth going into this in some detail to help you take it all in — but we'll do it in a practical way, with you as the guineapig.

I suggest you go through the following positions, preferably in front of a mirror: first, just stand up and try to imagine what your bones are doing — the straight, upright spine is supporting the thorax and the pelvis and the heads of the two femurs (thigh bones) are set firmly in the two pelvic cavities. It looks almost as if the femur, the tibia and the bones of the foot are one solid piece.

Now move the right leg backwards a little, taking the full weight of the body on this leg and relaxing the left with the knee slightly bent. Think about what your bones are up to now. Because the leg has moved backwards and taken the full weight, the skeleton has lost one of its props — it may wobble for a second. The pelvis has been tilted towards the left, thrust outwards and supported by the right femur (thigh). The thorax is also affected by the loss of support on the left side and has tilted towards the right. So we've got the pelvis tilted one way and the thorax tilted the other.

Whenever the body is in motion, or in a kneeling or sitting position, the hip position adjusts itself naturally to counterbalance the weight of the body. Whenever you are drawing the figure from memory, you should ask yourself which leg is taking the weight — and act accordingly. Bear in mind that the amount of support can vary: it can be complete, in a leaning, relaxed attitude (fig. 27A), or it can be partial, as in fig. 27B. And of course, in certain positions, the weight falls fairly and squarely on both feet — for instance, when you stand firmly with legs apart — in which case no special hip position is involved.

Practise with drawings like those in fig. 28 opposite, trying to see the whys and wherefores of each position. Keep an eye on the perspective of the thorax and pelvis sections, when they are tilted backwards and forwards, as well as left and right, always relating their position and angle to the posture of the body as a whole.

DRAWING THE FIGURE IN ACTION

Lastly, still working with diagrams, draw the figure in various attitudes of motion — moving freely, running, going upstairs, flopping into a chair, sitting lost in thought, in conversation, gesticulating, scuffling and being knocked onto the floor (see figs. 29 and 30). Practise drawing these and other positions, thinking up new attitudes and gestures. And pay attention to those proportions!

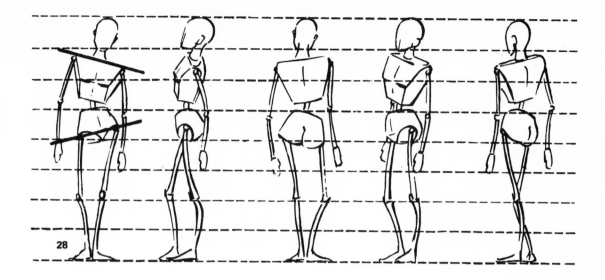

28

When you are working at these exercises, bear in mind that the shapes can be considerably simplified, but don't simplify them so drastically as to kill all the life and movement. In fig. 30 overleaf, you'll notice that in some cases I've indicated the waistline and in others I've slightly modified the basic 'swimming trunk' shape in an effort to represent a living person instead of an uninspiring textbook diagram.

I cannot over-emphasize the importance of practising what you've learned really thoroughly before going on.

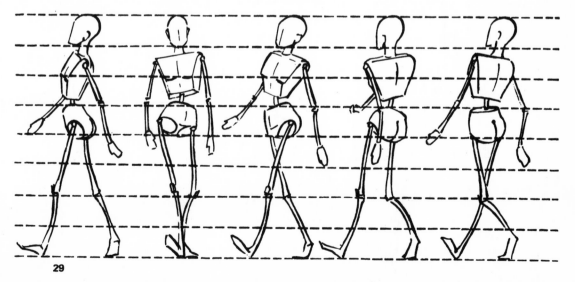

29

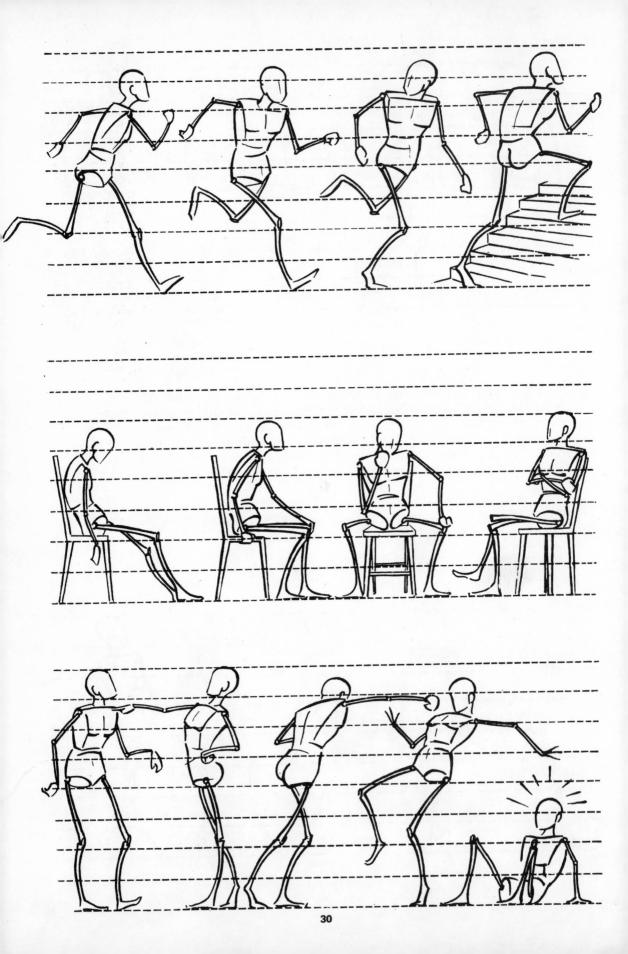

30

THE WOODEN LAY FIGURE

I've already mentioned the jointed metal puppets one sometimes comes across in art shops, my main criticism of them being that they are not sufficiently lifelike. What I didn't say was that they are probably made like this to keep down costs and put them within the pocket of the average artist.

You will also find — and they've been around a long time — jointed lay figures. These are designed for the draughtsman and are made — proportions, joints and all — in careful detail, so that the lifted leg, for example, contracts and bends exactly like a real one, the elbow joint produces really lifelike movements of the arm and forearm, and so on. But these lay figures are extremely expensive! A 12" high wooden one, as illustrated in fig. 31, would set you back the little matter of about £3.95. It's almost unbelievable, but they cost about as much as a small chainstore transistor radio. If you should ask why something like this — with absolutely nothing new about it — should be so expensive, you'll probably be told the shopkeeper doesn't know, or that it's because it's handmade by a craftsman. And I suppose that's the long and the short of it — lack of mass production. We tried to get an estimate for the kind of moulds which would be needed to mass produce these figures in plastic. The figure was around £600. 'And anyway, sir they'd have to be imported'.

31

It's a great pity that something so useful should cost such a lot of money. The fact is that these jointed figures can be an absolute boon to the artist drawing from memory and are ideal for training and tuition. We applied our minds to the apparently insuperable price obstacle and found a solution which we hope may be helpful:

THE HUMAN FIGURE:
PLAN 2, WITH A JOINTED PAPER MODEL

As we hope to show, manufacturing a jointed model out of paper with a few bits of wire is quite easy if you can summon up a little ingenuity. After a lot of experimenting we have come up with the method described overleaf.

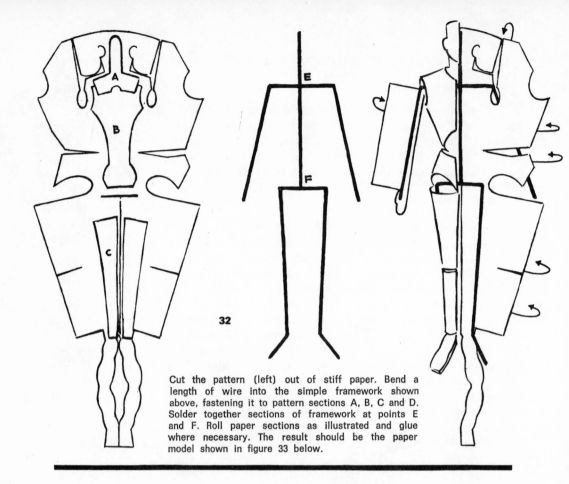

32

Cut the pattern (left) out of stiff paper. Bend a length of wire into the simple framework shown above, fastening it to pattern sections A, B, C and D. Solder together sections E and F of framework at points E and F. Roll paper sections as illustrated and glue where necessary. The result should be the paper model shown in figure 33 below.

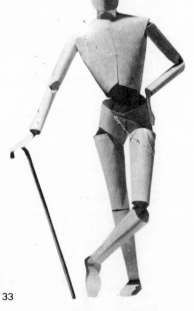

What do you think of our model (fig. 33)? Isn't it really just what we need as an aid to figure drawing from memory? I'm quite convinced of the value of this do-it-yourself lay figure which I believe can be a tremendous help to us. Set it on its feet and start considering something that should always be at the back of our minds, whatever we're drawing. I mean, of course, the law of:

* PERSPECTIVE

Our paper model really comes into his own when we begin studying the importance' of perspective in figure construction. We already know that the human body is composed of a series of cylinders — this little figure provides us with our object lesson.

Can you remember the proper way to construct a cylinder in perspective? Do you recall how different it appers when seen from above or from below? A glance at fig. 34 will 33 refresh your memory.

* For a comprehensive study of perspective, we recommend an earlier book in this series: *How to draw perspective.*

It shows a series of small cylinders (they look like tinned fruit cans) stacked one above the other, but with spaces in between each one. *What concerns us here is not the actual construction of the cylinders themselves, but the fact that, the further they are from the horizon line, the more you can see of their round tops (or bottoms, because the ones above the horizon line show their lower circular planes, while the ones below the horizon line present their upper circular planes).*

You get the same perspective problems with the human figure. The construction of the torso and, particularly, the arms and legs, is based on the construction of cylindrical sections seen in perspective. Fig. 35 below shows that if we fix the horizon line at head-level (imagining we are close to the figure), we get the same sort of perspective in the figure as we did with our fruit cans — the circular planes appear more or less foreshortened according to their distance from the horizon line.

Fig. 36 below is another illustration of the workings of perspective in figure construction. And here there's a new and important point: the perspective effect on the figure seen from above is the same as that when it is seen from below — perspective, in fact, governs the appearance of the body as a whole. The line * of the shoulders (A) and the line drawn through the end of the feet (B) converge on one vanishing point.

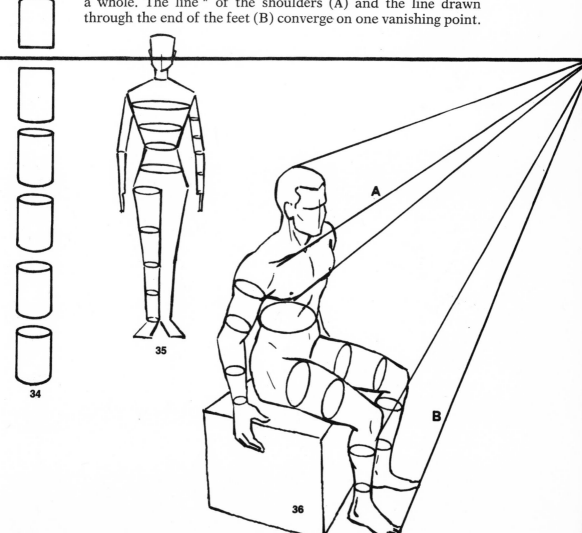

34

35

36

PERSPECTIVE: A GENERAL NOTE

Let's forget about cylinders and fruit cans for a while and imagine the figure enclosed by a parallelepiped or long rectangular block made to normal canon proportions: eight modules high by two wide and about one-and-a half deep. Place this imaginary block in perspective and you'll see how module lines A, B, C etc. gradually close up and converge on a vanishing point, marking out sections a, b, c.

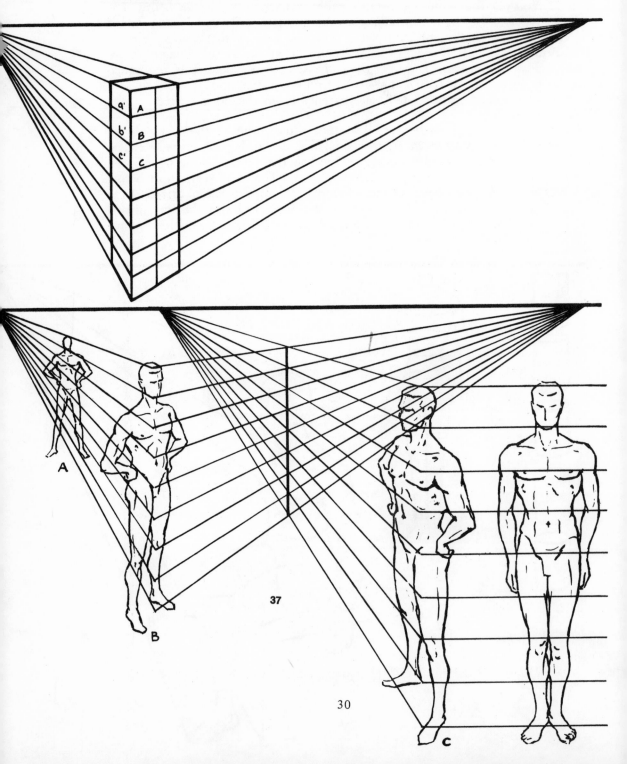

37

To do the same thing with a figure instead of a box, we need to take the various module lines of the body — at the shoulders, nipples, elbows, hips and so on down to the feet — extending each line to a point on the horizon and thus getting the perspective (fig. 37). Whatever our position, or that of our model, perspective plays an important role and is something to be taken into account.

Note the size-perspective relationship between figures A, B and C. C is proportionately larger than B, and B is proportionately larger than A, i.e. all three figures are placed in correct perspective in relation to a set horizon line.

While we're on this subject, let's look at the fascinating problem of:

PERSPECTIVE WITH MORE THAN ONE FIGURE

The artist is often set the task of drawing several figures in one picture, at different distances from the horizon. This is the way to do it:

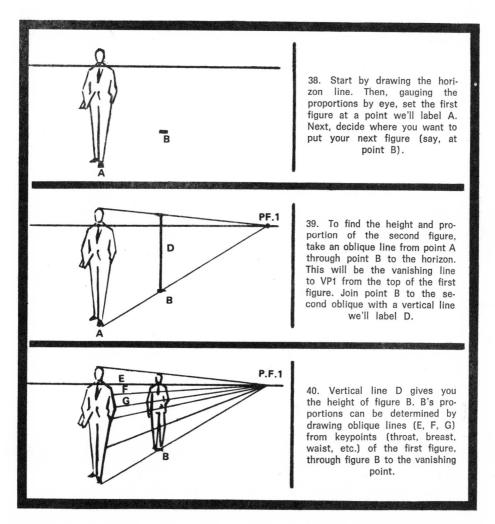

38. Start by drawing the horizon line. Then, gauging the proportions by eye, set the first figure at a point we'll label A. Next, decide where you want to put your next figure (say, at point B).

39. To find the height and proportion of the second figure, take an oblique line from point A through point B to the horizon. This will be the vanishing line to VP1 from the top of the first figure. Join point B to the second oblique with a vertical line we'll label D.

40. Vertical line D gives you the height of figure B. B's proportions can be determined by drawing oblique lines (E, F, G) from keypoints (throat, breast, waist, etc.) of the first figure, through figure B to the vanishing point.

31

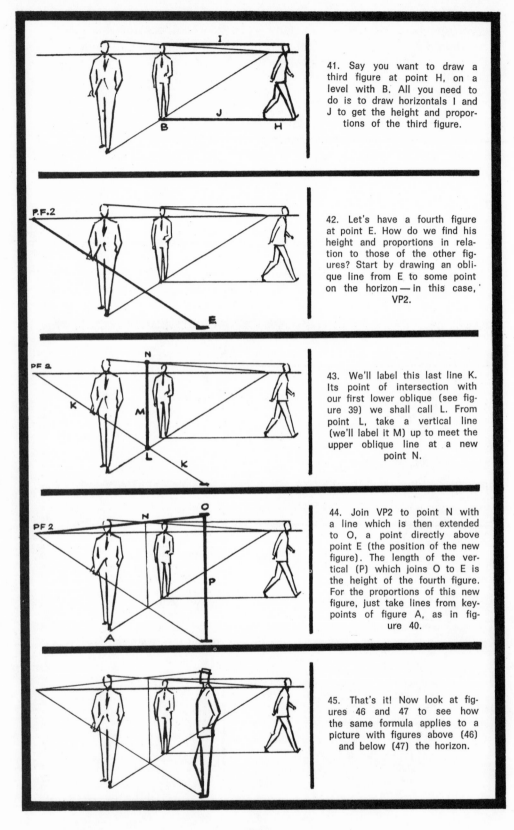

41. Say you want to draw a third figure at point H, on a level with B. All you need to do is to draw horizontals I and J to get the height and proportions of the third figure.

42. Let's have a fourth figure at point E. How do we find his height and proportions in relation to those of the other figures? Start by drawing an oblique line from E to some point on the horizon — in this case, VP2.

43. We'll label this last line K. Its point of intersection with our first lower oblique (see figure 39) we shall call L. From point L, take a vertical line (we'll label it M) up to meet the upper oblique line at a new point N.

44. Join VP2 to point N with a line which is then extended to O, a point directly above point E (the position of the new figure). The length of the vertical (P) which joins O to E is the height of the fourth figure. For the proportions of this new figure, just take lines from keypoints of figure A, as in figure 40.

45. That's it! Now look at figures 46 and 47 to see how the same formula applies to a picture with figures above (46) and below (47) the horizon.

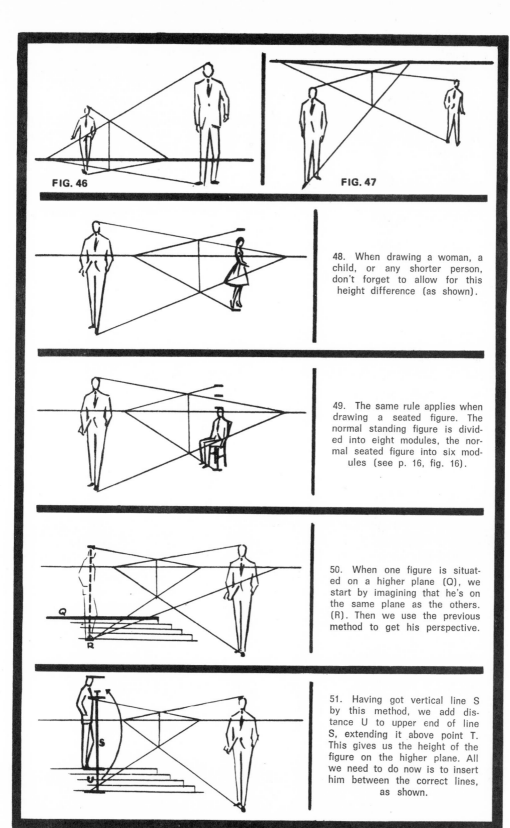

FIG. 46

FIG. 47

48. When drawing a woman, a child, or any shorter person, don't forget to allow for this height difference (as shown).

49. The same rule applies when drawing a seated figure. The normal standing figure is divided into eight modules, the normal seated figure into six modules (see p. 16, fig. 16).

50. When one figure is situated on a higher plane (Q), we start by imagining that he's on the same plane as the others. (R). Then we use the previous method to get his perspective.

51. Having got vertical line S by this method, we add distance U to upper end of line S, extending it above point T. This gives us the height of the figure on the higher plane. All we need to do now is to insert him between the correct lines, as shown.

33

That's enough about perspective. Please study and assimilate the diagrams in the last few pages before we go on.

USE THE PAPER MODEL

By now, you should have all the information you need to start practising with the little paper figure. You know by now how the parts of the body fit together. A propos of this, do you remember how to use the module lines to find those reference points to various parts of the body? Don't forget them — they're the best method for dividing up the human figure. So: you know how to find the proportions — using a judicious mixture of your own impression of the model and your knowledge of the ideal figure. You know how the human figure is governed by perspective — you'll be able to imagine a horizon and visualize the lines of the body converging on their respective vanishing points.

Go along with me... setting up your model in different positions and practising what you've learnt.

KEEP IT LIFELIKE!

When you're considering poses for your model, make sure they could really happen naturally. You obviously won't be bending things in impossible directions — bending the arm backwards, for example, as if the elbow were back-to-front — because such a movement would be a physical impossibility. But do keep a watchful eye on things in general, noting how far the arm can really stretch, or how high the leg can be raised. And keep the body movements within the realms of possibility. Remember, for instance, that:

52. When a figure is walking or running, the arms swing in the opposite direction to the legs. When the right leg moves forwards, the right arm swings backwards, and vice versa.

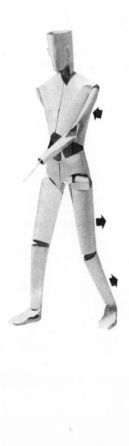
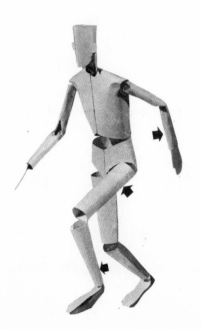

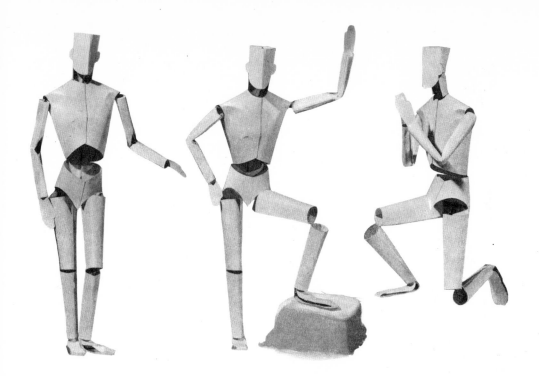

53. The hip position (p. 23) must be taken into account in nearly all stationary positions and attitudes of repose.

54. The body balances itself instinctively. Lifting, thrusting arm movements automatically counterbalance movements of the trunk in any direction.

Where do we go from here? On to the real figure in action — including all the muscles in action too, of course — and all drawn from memory. The main problem set in this final exercise is how to tackle foreshortening in a line drawing.

USING EXTENDED LINES TO SUGGEST FORESHORTENING

Compare figures 55 A and B below. In both, the foreshortened arm is drawn in outline — with no light or shade. In fig. 55 A, not much attention has been paid to the contours and for this reason the foreshortening is not immediately apparent. In fig. 55 B the foreshortening has been

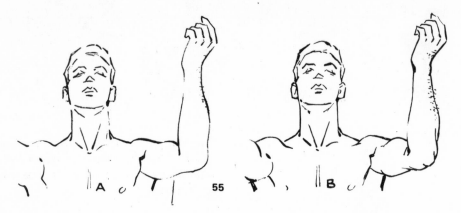

clearly delineated by extending the lines of one contour a little into the next, giving a brief indication that here there is a slight fold, a little gully of flesh into which the next contour line gently slides.

DRAWING A LIFELIKE FIGURE FROM MEMORY

This is our goal. First we must complete a properly lined up and proportioned sketch, using the paper dummy as model. Get the muscles in the right places and try to see how they would actually appear — the shapes of the pectorals, deltoids and biceps. Think of the symmetrical centre of the body — and remember it. Sketch in a faint perspective guideline and draw in the muscles. This demands a good grasp of anatomy — the only proper basis for figure drawing. Experiment... draw... re-draw. (See my sketches on the next pages.) Difficult? Yes, but it'll come with practice.

I suggest you begin your final study by drawing the real figures first in front view, then in three-quarter and back view. Then set the paper model into positions of motion, drawing it from different angles, until you graduate to drawing it seated and running. Place the dummy on a

56

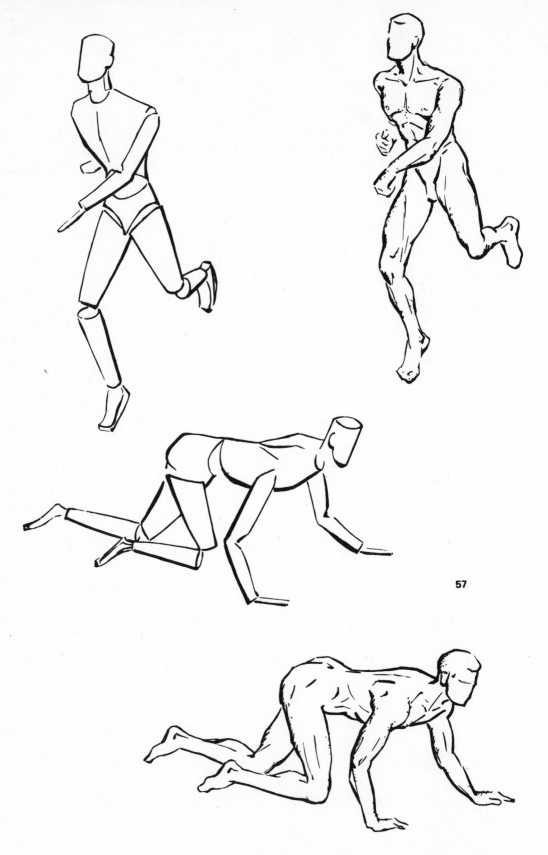

57

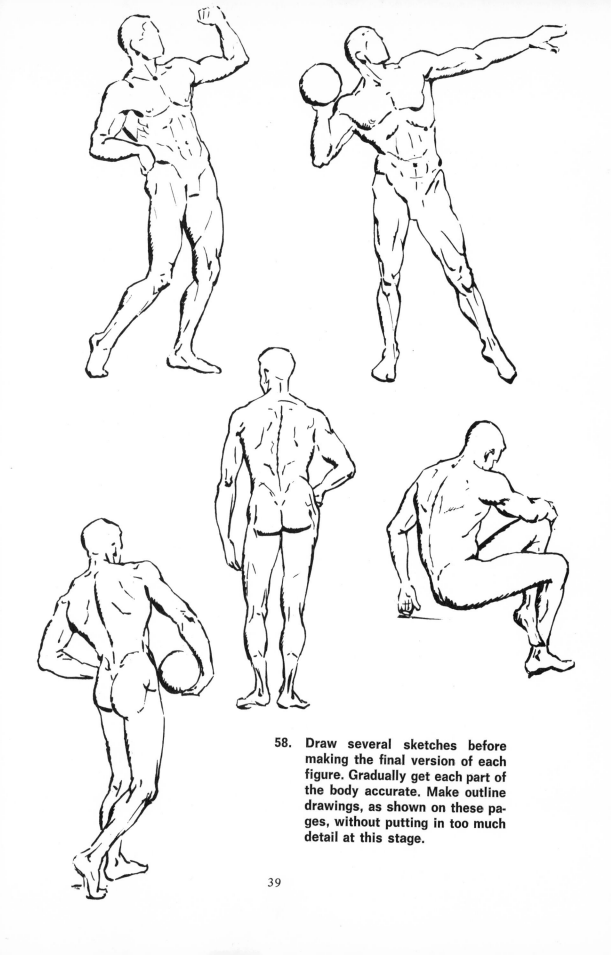

58. Draw several sketches before making the final version of each figure. Gradually get each part of the body accurate. Make outline drawings, as shown on these pages, without putting in too much detail at this stage.

59. The female figure has more prominent bust, hips and buttocks than the male. The shoulders are narrower and the other contours are altogether more rounded, more svelte and less muscular. The lines are lighter, more delicate and generally more feminine.

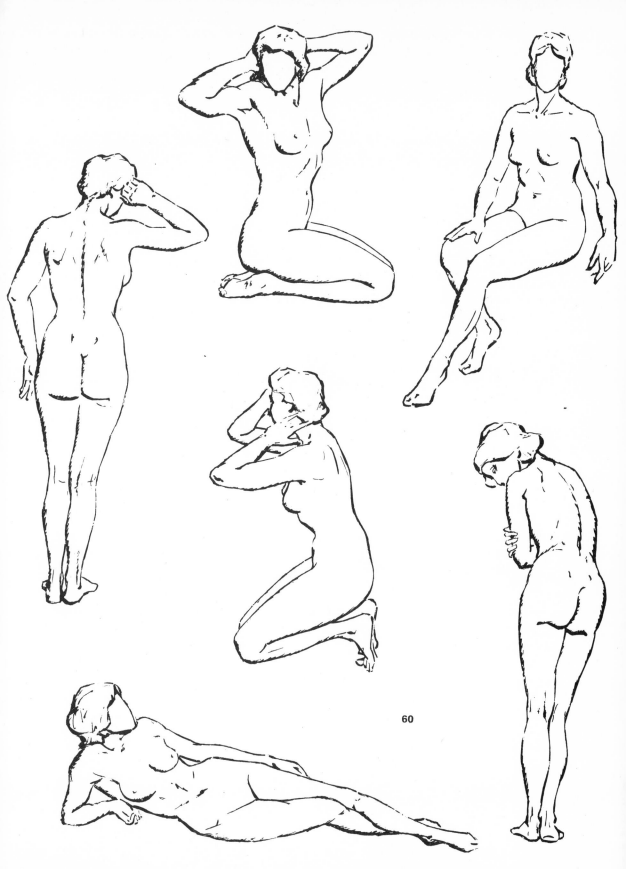

60

41

box or a pile of books to begin with, so that it's more or less at eye-level and you don't have too many difficulties with perspective and foreshortening. Then progress by stages to more difficult angles, more complex positions. Picture yourself as rising to great heights from small beginnings: it can be done.

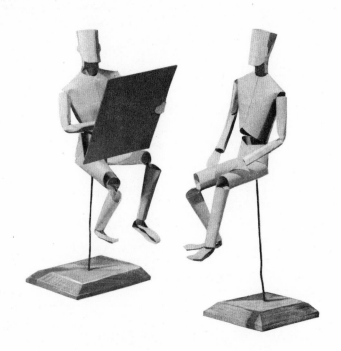

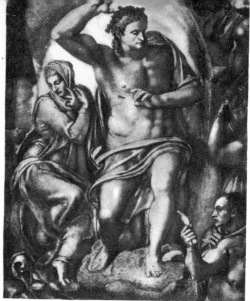

The Last Judgement, Michelangelo, detail.

MORALITY AND THE NUDE IN ART.

In the city of Venice, on 18 th July, 1573, the artist Paolo Caliari, known as Veronese, was summoned to appear before the Inquisition.

Veronese was charged with having painted a picture, *The Last Supper*, whose characters included «a debauched-looking servant, a dog in the act of lifting its leg, a fool with a parrot and other figures in attitudes of irreverence and profanity». In his defence, the artist said that: «he felt bound to follow in the traditions of his predecessors».

According to Venetian city archives, the exchange went like this:

Inquisitor: «Is there, in fact, any precedent for a work of this kind?»

Veronese: «Yes: Michelangelo's *Last Judgement*, in the Sistine Chapel. Michelangelo painted Our Lord, The Blessed Virgin, St John, St Peter and all the heavenly host completely unclothed in this masterpiece».

Inquisitor: «Are you not aware that *The Last Judgement*, in which all the figures are uncovered, was painted not for the purpose of depicting garments, but as an expression of complete spirituality?»

This last remark resounded throughout the length and breadth of Italy, turning into one of the most impassioned arguments in the history of art — the question of the morality of the nude. Veronese's opinion was completely disregarded and he was commanded to alter the painting

43

of The Last Supper at his own expense. The really far-reaching and significant outcome was the Inquisition's defence of Michelangelo's unclothed figures. .

Let's consider the implications for a moment.

In *The Last Judgement* Michelangelo painted a total of 314 figures, presided over by the central figure of Christ with the Virgin Mary and the Apostles, surrounded by angels and saints. Every one of these figures was completely unclothed.

Michelangelo's conception of the subject had had the approval of Pope Paul III — who had commissioned the painting. But when it was unveiled, a storm of protest arose — to say nothing of a few panegyrics — and the work was declared «obscene, lewd, indecent and scandalous». The controversy lasted some 23 years, until 1564, when the new Pope, Pius IV ordered that the naked figures should be decently veiled. But let's be clear about one thing: the contradiction of these two judgements shows that, only one year before the Inquisition had made this final decree — the most extreme and authoritarian decree to be made on this subject — there had been no question of defending the morality of Michelangelo's nude figures.

Was the Inquisition right? Surely it was right when it stated that there was nothing immoral in nudity per se? Time, discussion and the weight of public opinion have since shown that there is nothing immoral about nudity in art... as long as the art is truly art and the aesthetic outweighs the sensual.

Students in art schools study the nude from life with female models who are completely nude and males wearing briefs. There's no segregation of the sexes in our art schools — and the students include priests and religious in teaching orders who are studying art.

I'm sure we can assume that you — as intelligent amateur artists — will find no problem in approaching the question of nudity without ignorant prejudice. Of course it is possible to look upon nudity and see nothing but the beauty of the human body. If this isn't true of you, don't bother to go any further. I'd advise you to forget the whole subject and realise that you're not cut out to be an artist. Because art and obscenity — like intellect and stupidity, light and darkness — simply cannot walk hand in hand.

Light and shade in figure drawing

You know by now that objects are 'modelled' by light, the light bringing out their shadows and the shadows they cast. Lighting can be natural or artificial, diffused or direct. It can come from several direction. Depending on its quantity, quality and direction, it can create a greater or lesser contrast or relief and has, in fact, a very great influence on the finished work. Within the shadowed parts themselves are found variations of tone which build op the chiaroscuro, or balance of light and shadow. These variations are governed largely by the reflections of the light itself.

Quantity, quality and direction of the light — these are the three

Michelangelo's **The Last Judgement,** painted on a wall of the Sistine Chapel in Rome. It is 95' wide by 50' high.

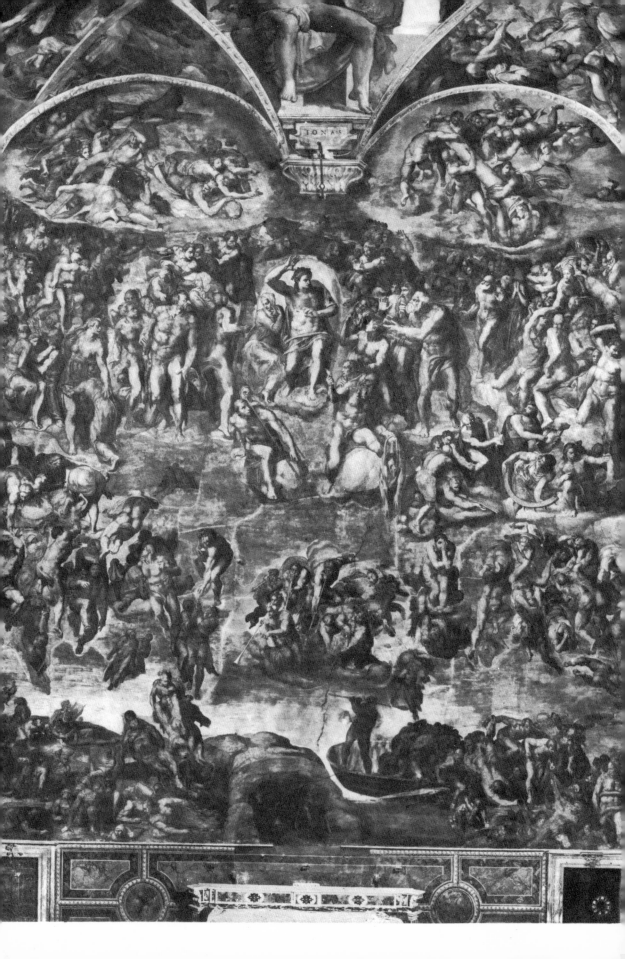

principles you should bear in mind when considering the effects of light and shade in figure drawing. They exert their influence right from the start, requiring the artist to decide whether his treatment is to be harsh or smooth. Of course, he still has to assess for himself the tonal values and variations in the shaded sections.

Let's move on without more ado to a practical study of shading as it affects figure drawing.

SHADING BY PLANES OR SECTIONS

Imagine that your model is the Venus de Milo and suppose that you've already decided on the boxing up and construction and have reached the point where you must start modelling, or suggesting the relief and the chiaroscuro. (Obviously these two operations — getting the impression of the outlines and the shadows — can and should be done at the same time. In this example we've separated them for practical purposes.)

We're faced with the problem of rendering in the first sketch the model's whole range of tonal values. Notice in the model opposite, for example, the subtle gradations of shading which hint at the cylindrical shape of the arm, the smooth curves of the torso, abdomen, hips and so on. As you can see, there are no sharp edges — the areas blend into each other in the most regular way. Of course, it's impossible to get all this subtlety and integration of tone in one go — you have to concentrate at different times on the contrasts between the various parts.

The one practical way of getting round this problem is to see the limits and boundaries of the shaded section — or, rather, to know to see them. You have to be able to glimpse them, as it were, without all the half-tones, to get brief impressions of clearly defined areas of light and shade; you have to be able to see them as if they were planes, as if the figure were faceted like a diamond.

Fig. 61 opposite illustrates this. We must think of A without the shading, imagining the shaded parts as lots of differents planes. Figure C shows the shadow-plan for figure B. Figure D shows the gradually modelled figure nearing completion, its shading based on the work done in figure C.

That's fine, you say, but how on earth am I supposed to see something which isn't there? How can I look at shadows and see them as planes? Possibly this approach *would* help me — but how do I manage it? Well, it's not really all that complicated. You start by gauging the limits of the shadows — deciding where light ends and shade begins. Figure 62 — a series of tonal gradations — shows how this can be done smoothly. You'll see how easy it is to make something definite out of something subtle — for example, to see that B is the dividing line between light area A and the darker area C, and that D is the limit of area C and the start of area E. Suddenly there's no problem, though of course we must remember that it's just an impression of shadow we're concerned with here. What we also need is an impression of volume. And there is an accepted method for defining these theoretical boundaries of light and shade.

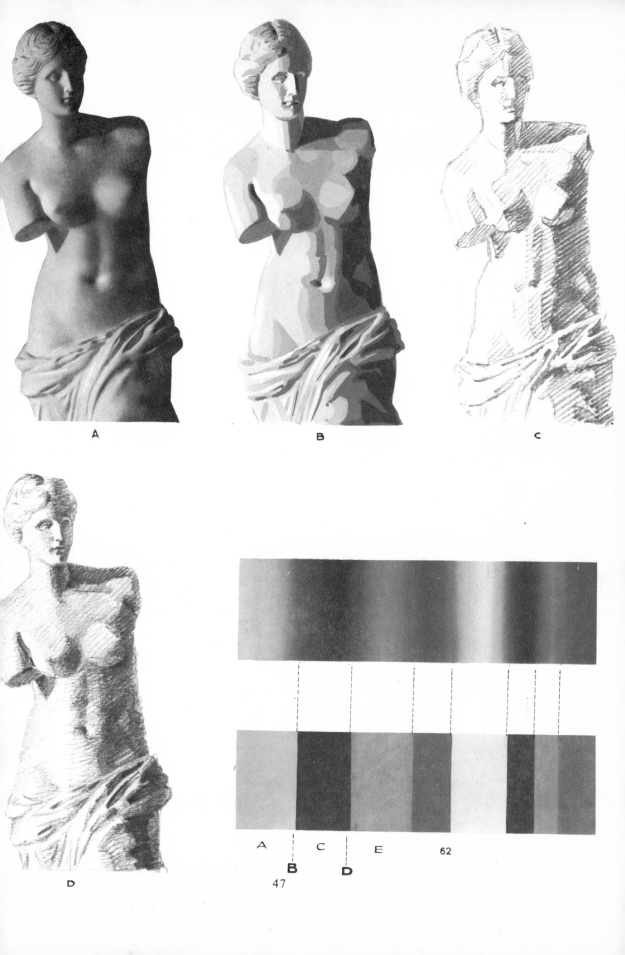

A

B

C

D

A C E 62

B D

47

Half close your eyes and blink rapidly, several times. You'll find you don't really see the half-tones, getting a much clearer impression of the shading — something approaching the shading-by-planes method.

Do try this trick of looking at your model through half-closed eyes to discern clearly defined patches of light and shade.

BACK TO THE DRAWING BOARD

Having got that over, you needn't worry that the shading-by-planes method demands a study of geometry — we are not, after all, proposing to turn the human figure into a polyhedron. Obviously, theory is one matter and practice quite another. When we're actually working, we take this splitting up or synthesis of curved surfaces into separate planes as something to keep at the back of our minds. Let's use fig. 63 as our model and go on from there.

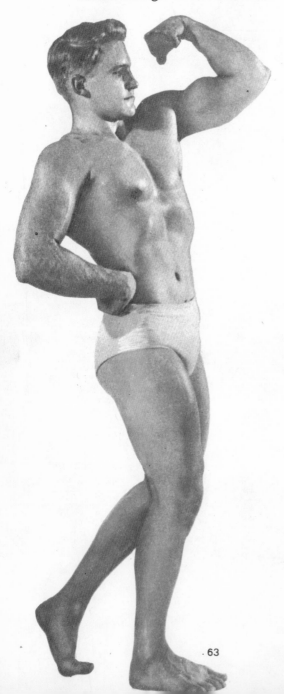

Figure 64. — Here is our figure in its initial stages of construction and shading. (I emphasize once more the advantages of combining these two operations.) The shading-by-planes method has been used. Boundaries between light and shaded areas have been marked in line A and tone has been laid uniformly with broad, oblique strokes, using a chisel point, with the end of the pencil cupped in the palm.

Figure 65. — Working within this whole shaded area, we emphasize the darker edges of the shaded parts — the previously mapped-out planes (line B). At this stage, uniformity of the darker areas is achieved by slightly altering the direction of the pencil strokes. We complete the process, using half-tones to fill in the planes in marginal shadow.

48

.63

Notice in fig. 65 that the light and dark areas usually have no clearly defined edges. (Compare this with fig. 61, p 47.) In fig. 65 you'll see some areas with curved, looped or darker shading strokes, suggesting the curved, cylindrical shapes right from the beginning. So please bear in mind that the shading-by-planes method shouldn't be taken too literally, and that, while you should be familiar with the textbook theory of reducing subtly gradated shades into clearly defined section, you must be very discriminating in the application of this theory.

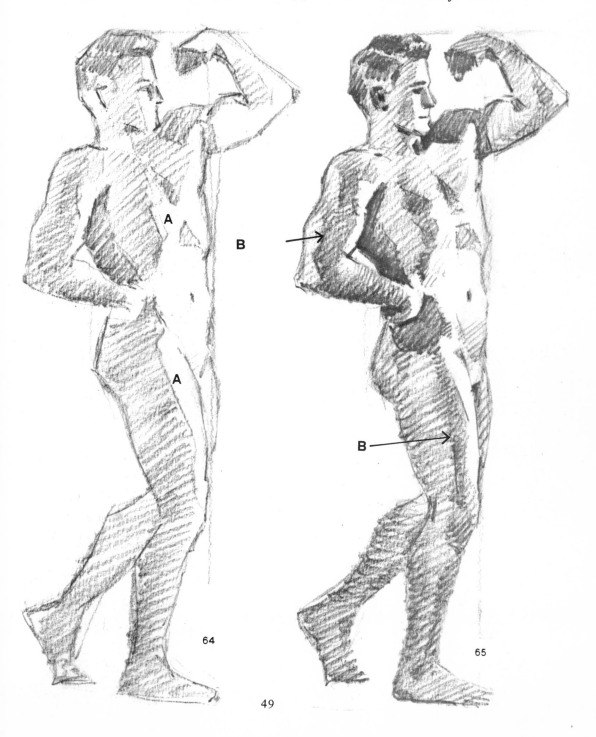

64

65

THE ACADEMY FIGURE

Let's continue our study of light and shade by looking at the way in which toning, contrasts and atmosphere are gradually developed when you draw an academy figure. This term 'academy figure' stems from a style adopted by artists in the last century — Ingres is the most representative example — who took great pains to draw and paint with absolute realism, reproducing the shapes and values of the model with objective precision. Nowadays, this style is used mainly by students for pratical exercises.

It's the best style for us at this stage and we'll use it to provide a a firm foundation for the study of modelling the human figure — the roots of the skill we'll develop into a personal style later on.

Let's go over the basic rules for producing perfectly accurate academic modelling. When we appraise *a tone, we assess and concentrate upon one of the model's tonal values until it's engraved in the memory and can be held up and compared with others.* In order to do this we must first be able to see and graphically suggest the light itself, analysing the model as a composition of shaded surfaces and always seeing tones instead of lines. Toning, construction, harmonization and finishing must be done gradually and simultaneously so that the picture is being built up in general and in detail at the same time. A study and comparison of contrasts between some tones and others is also needed. Remember the rule of *simultaneous contrasts,* i.e. that 'white becomes whiter as the surrounding tone is darkened'. And contrasts can also be created by intensifying one or two adjacent tones so that one of them is highlighted. The softening of outlines can create a feeling of atmosphere by emphasising the clarity of the foreground planes and slightly blurring those in the background.

STRENGTHEN THE TONES OF HEAD AND LIMBS

When drawing from the nude I have usually found that the scale of values is slightly higher in the head and limbs than in the trunk. The head and hands are nearly always a little darker — a very little — than the rest of the body, the darker tone developing gradually from arm to hand and from knee to foot. This generally produces a natural effect, since forearms hands, legs and feet, as well as the head, are the parts of the parts of the body most exposed to sun and air.

SOME SPECIFIC EXAMPLES

We've included as illustrations the following figures drawn in the academic style, including the superb study on page 53 by the Spanish artist Mariano Fortuny. You'll notice in these drawings that the position and shape of each muscle has been emphasised. The result — a living image of the human body (figs. 66, 67, 68, 69, 70, 71, 72 & 73).

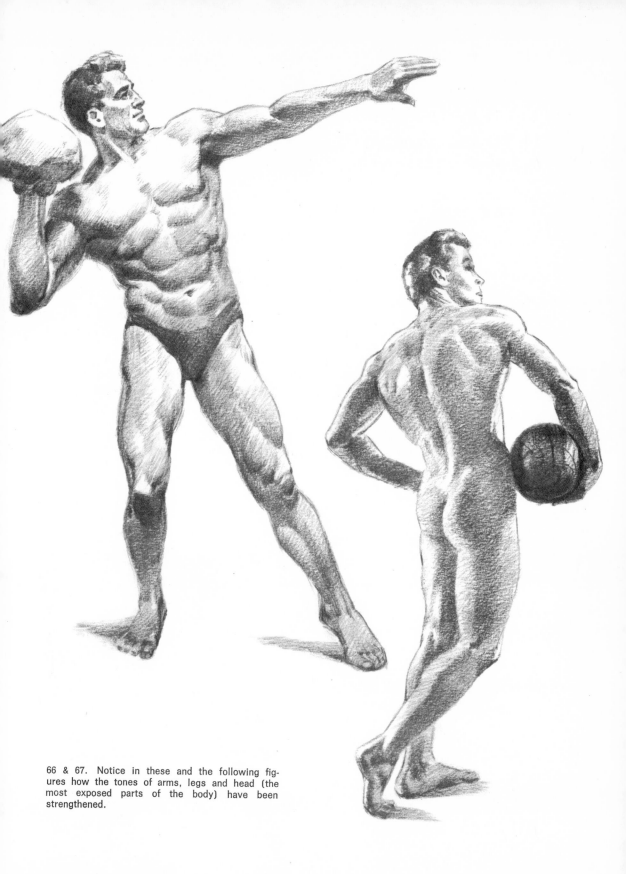

66 & 67. Notice in these and the following fig-
ures how the tones of arms, legs and head (the
most exposed parts of the body) have been
strengthened.

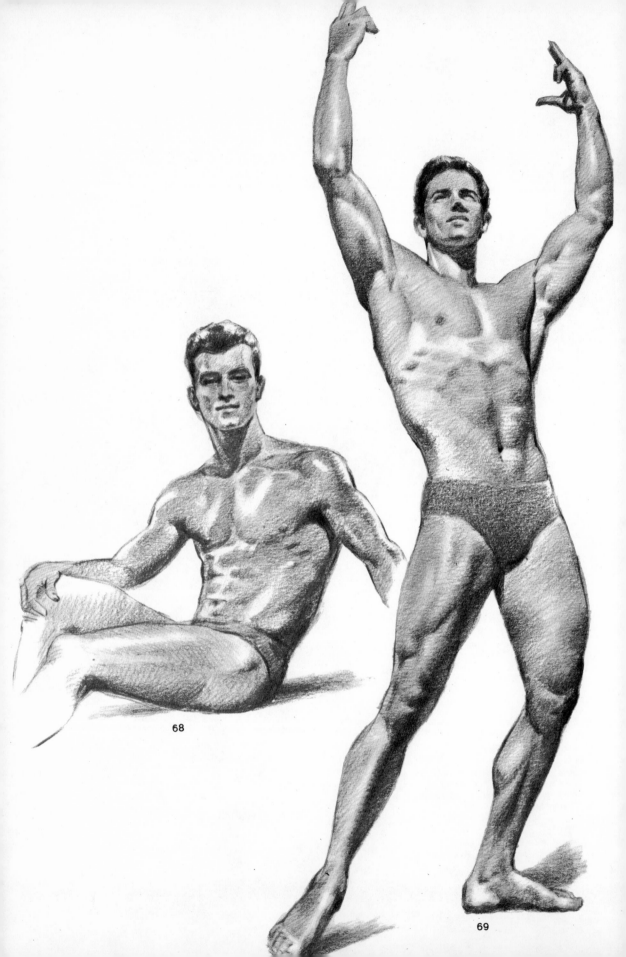

68

69

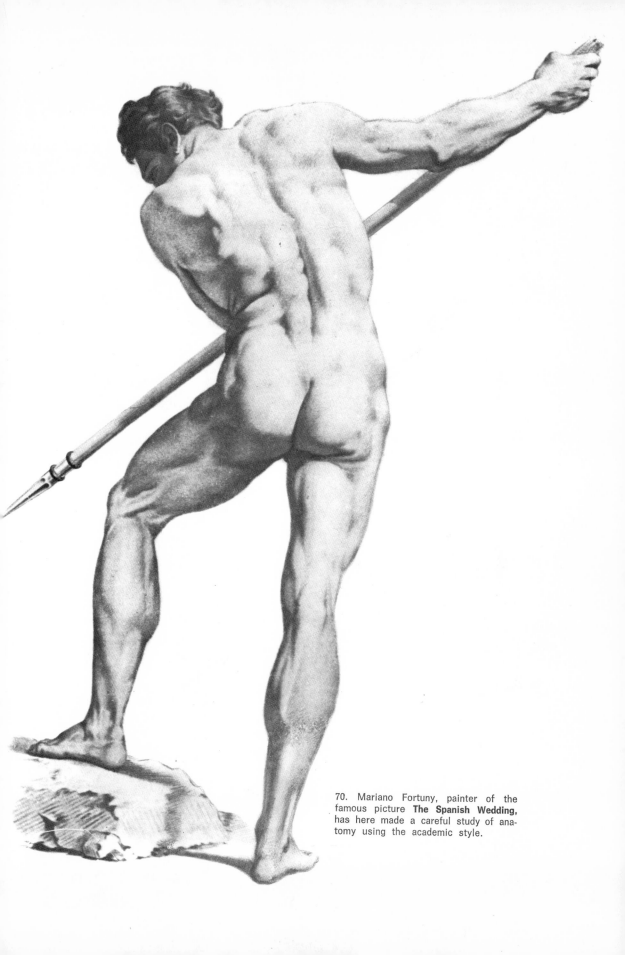

70. Mariano Fortuny, painter of the famous picture **The Spanish Wedding,** has here made a careful study of anatomy using the academic style.

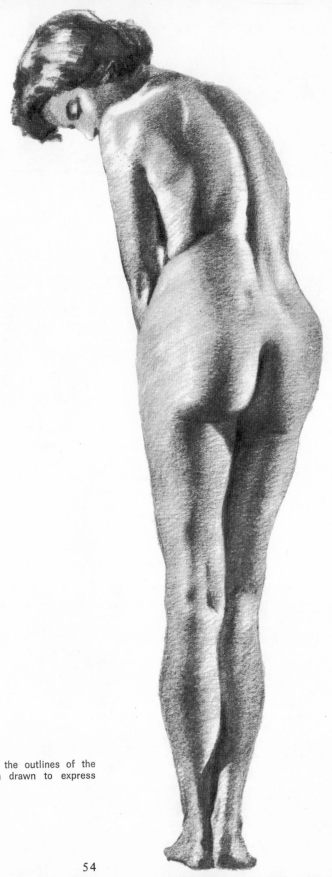

71 & 72. See how carefully the outlines of the highlighted areas have been drawn to express the exact shape of the body.

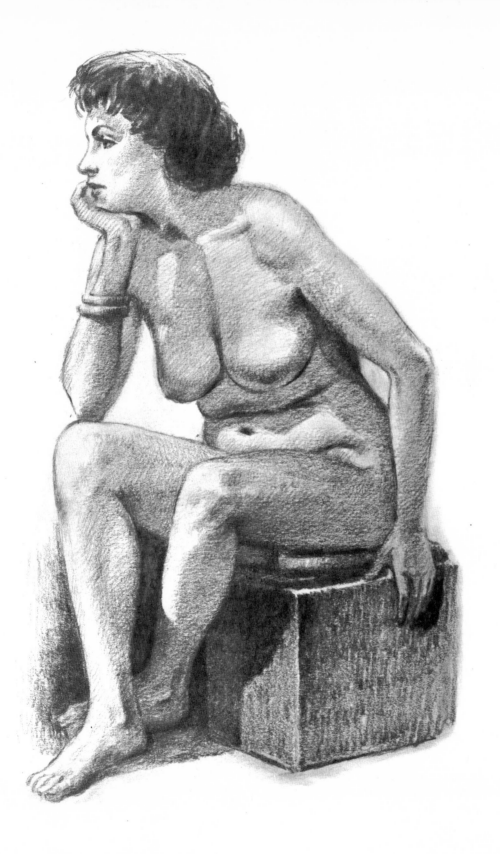

INDIVIDUALITY OF STYLE

It's very early days to start talking about individuality of style — your own personal and distinctive way of drawing. However, as we're nearing the end of our study of figure drawing, we'll give it a little time at this point.

You'll know that by 'style' we mean the special character with which the artist imbues his works. It is the result of his interpreting the model in his own way, his drawing of its shape and tones in keeping with his ideas and feelings, his experience and state of mind, not forgetting the style in current fashion. To this personal interpretation of shape and tones he then adds his preferred working method — his handling — or particular use of technique and medium.

The artist can formulate his own style through stylization, modelling and handling. Let's take a look at each of these in turn.

STYLIZATION

The artist's vision or interpretation may be conventional or otherwise. It can lengthen, widen, harden, soften, idealize and many other things too. To work in a stylized way implies changing or distorting the appearance of the model... which can produce an unappreciated originality which may prevent contemplation and instead arouse anguish and pose questions. You will develop your own mode of stylization all right, but don't rush it. Wait for the impulse towards distortion which — if it comes at all — will come in its own good time when you have mastered the academic style, when you have drawn so many figures from life that you feel a pressing need to find new forms of artistic expression. This way you will be following the example of the old masters, El Greco, for instance, who was the first famous artist to dare to stylize and distort the human figure. And that did not happen overnight. If we compare one of his first paintings when he arrived at Toledo (*The Martyrdom of St Maurice*) with any from his later period (*The Baptism of Christ*, for example), we can see how these imaginative and superb disproportions did not just happen in a few hours, but were produced by constant development and study. (Figs. 73 & 74.)

MODELLING

Like form or stylization, modelling can be realistic or photographic in the academic style. But as a creative artist with a style of your own, you can approach and interpret it in your own way, according to your mood and the meaning and message of the work. You can emphasise and even harden contrasts, transforming the image into an interplay of black and white; or you can soften them, making them extremely subtle. You can alter the atmosphere by emphasising your personal approach and drawing with absolute precision and clarity and a strong, hard and cutting style — or you can exagerate the effect by softening the shapes and drawing them as if seen through glass. (Figs. 75 & 76.)

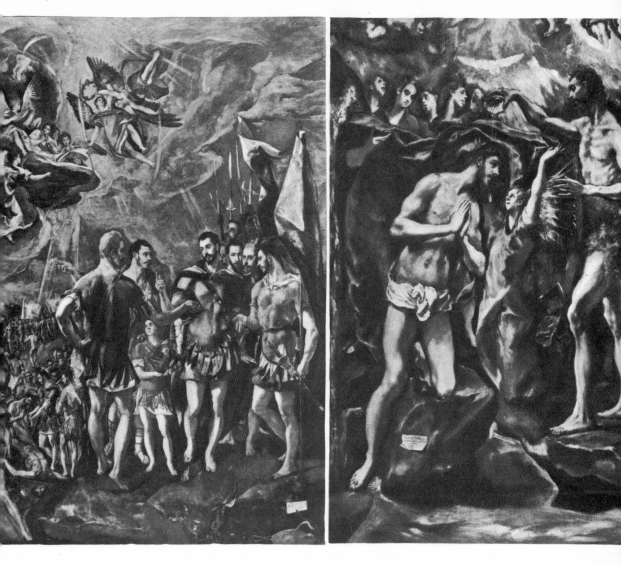

73 & 74. El Greco: The Martyrdom of St Maurice (Escorial) and the Baptism of Christ (Prado).

HANDLING, TECHNIQUE AND MEDIUM

The manner of handling is governed firstly by the technique — the way you draw lines, shade, blend, etc. — and secondly by your medium, which may be lead pencil, carbon pencil, red crayon or even ink with pen, brush or reed. Handling is always vital in determining the style; it is the stroke that counts, the character of the line or brush stroke — for example, the combination of rough paper and soft pencil, or blending done with short lines on a pencil-shaded background. (Fig. 77.)

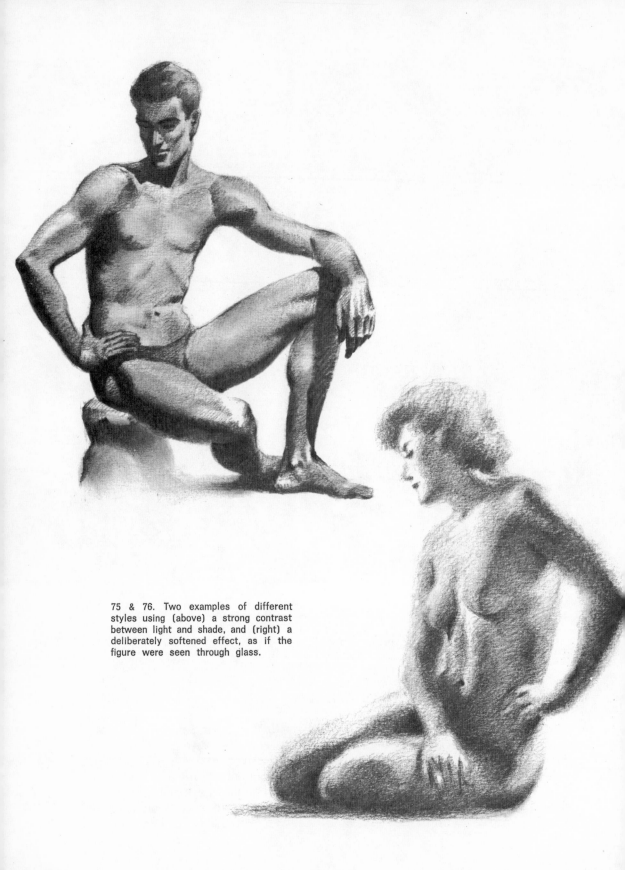

75 & 76. Two examples of different styles using (above) a strong contrast between light and shade, and (right) a deliberately softened effect, as if the figure were seen through glass.

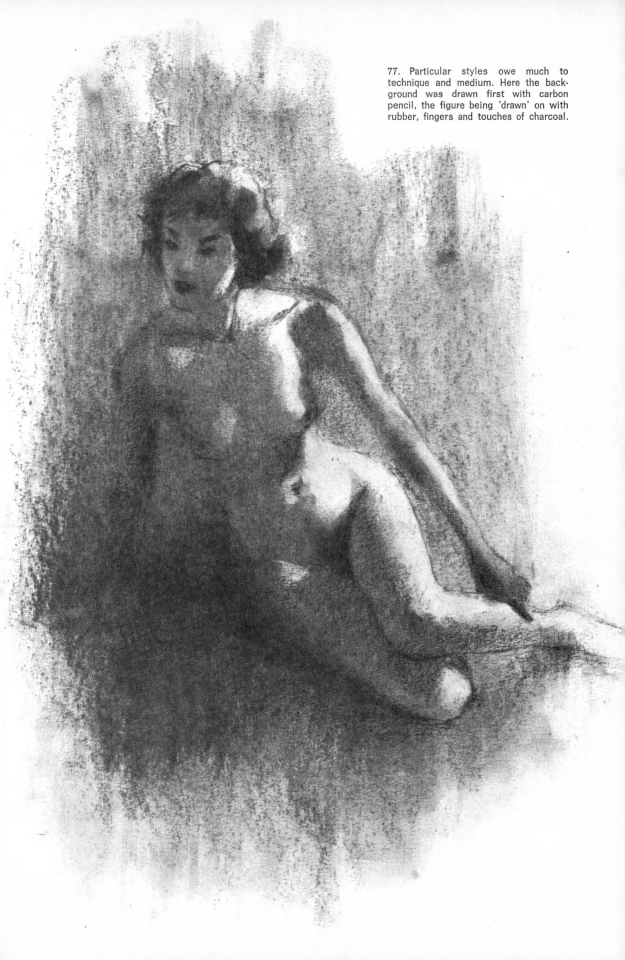

77. Particular styles owe much to technique and medium. Here the background was drawn first with carbon pencil, the figure being 'drawn' on with rubber, fingers and touches of charcoal.

THE HUMAN BODY — A DETAILED STUDY
Torso · Arms · Legs · Feet · Hands.

MICHELANGELO THOUGHT THE TORSO WAS OF PRIME IMPORTANCE

To Michelangelo, the part of primary importance was the trunk. In the words of Professor Stratz: 'If we study a large number of his sketches, it becomes clear that Michelangelo's point of departure was not the head but the trunk. In his figure studies, the hands, feet and head seem often merely suggested by light lines, while the trunk is drawn in full detail.'

We can understand Michelangelo's preference for this part of the body when we remember that, like a real anatomist, he was particularly concerned with the origin of movement which lies in the trunk. This was, for him, the vital aspect, and he felt the muscles of the trunk and the limbs which bend, twist, stretch, etc., were more important than the parts which *were* moved — the head, hands and feet.

As you can check for yourself, as long as the torso is properly formed and modelled, the other limbs produce no problems. Take plenty of time studying the torso; draw it from the front, or from the side with the waist twisted towards the front, and from the rear with the body bent to one side or with the figure seated, etc. Use yourself as a model (with a mirror) or get one of your friends to pose for you. If this is impossible, practise by copying the following illustration which show the torso in various positions, with emphasis on the muscular structure. (Fig. 78.)

ARMS AND LEGS — FOUR MUSCULAR CYLINDERS

The arms and legs provide a perfect example of the principle that 'the human body is composed of a number of cylindrical forms.' That is all our orms and legs are... with of course the corresponding appearance of the muscles on the surface and indications of the bone structure at certain points. In order to get the right shape from the basic cylinders, you need to be familiar with this muscular outline. Have a look at the studies of arms and legs I have drawn for you (page 62), noting the position and shape of the muscles in each example (fig. 79). An important point to remember in this connection, which influences the modelling of the trunk and, generally, all the essentially cylindrical parts, is that:

**The direction of the line follows
round the cylinder, encircling it.**

Be very careful never to draw the shaded areas on a cylindrical form (an arm or a leg) with vertical lines along the length of the cylinder as if it were a grooved tube (that's what it would look like!) Always use curved lines to encircle the cylinder, then shade it, still using

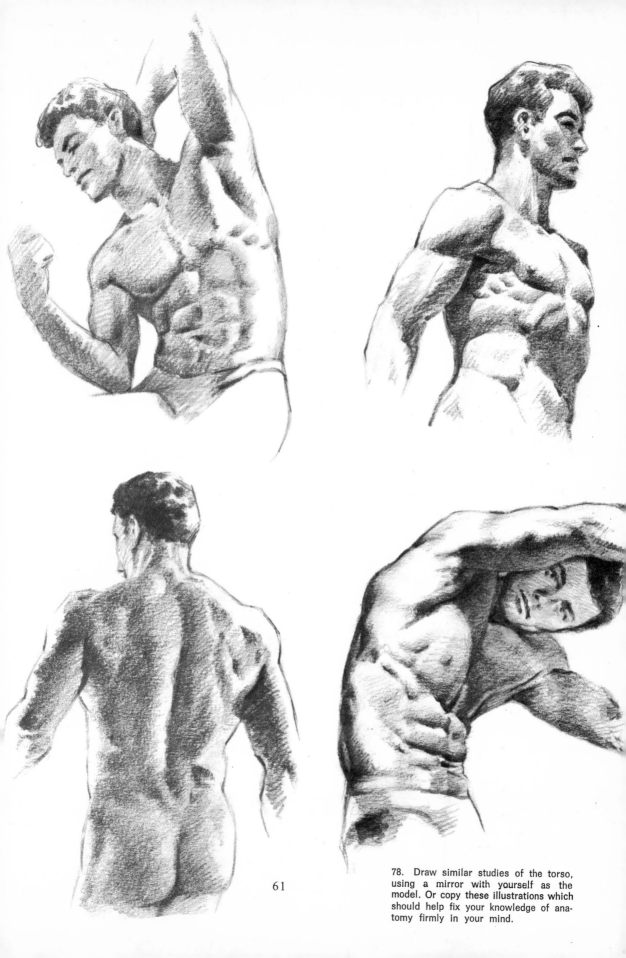

61

78. Draw similar studies of the torso, using a mirror with yourself as the model. Or copy these illustrations which should help fix your knowledge of anatomy firmly in your mind.

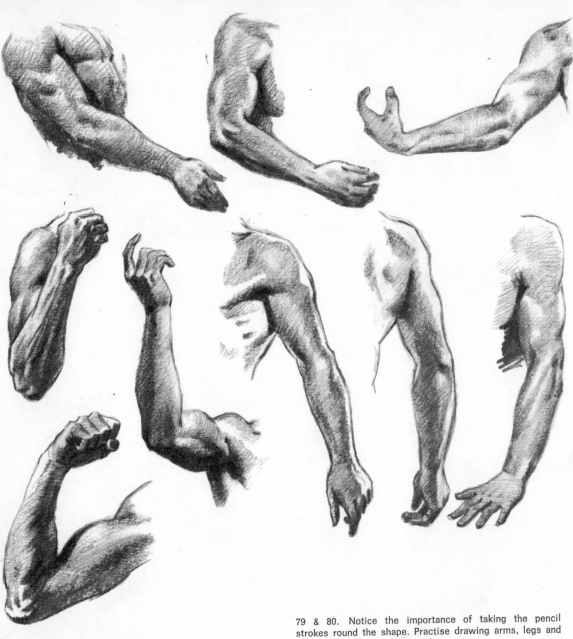

79 & 80. Notice the importance of taking the pencil strokes round the shape. Practise drawing arms, legs and feet, with shoes or without them.

circular movements with the fingers or a blender. Remember that when boxing up or producing grey tones, you can usually use diagonal hatching lines as well, but never use vertical lines.

THE COMPLEX SHAPE OF THE FEET

You can study this for yourself by drawing your own feet. When you have a moment to spare, take off your shoes and socks and look at your feet in a mirror, studying and drawing them. Their shape is

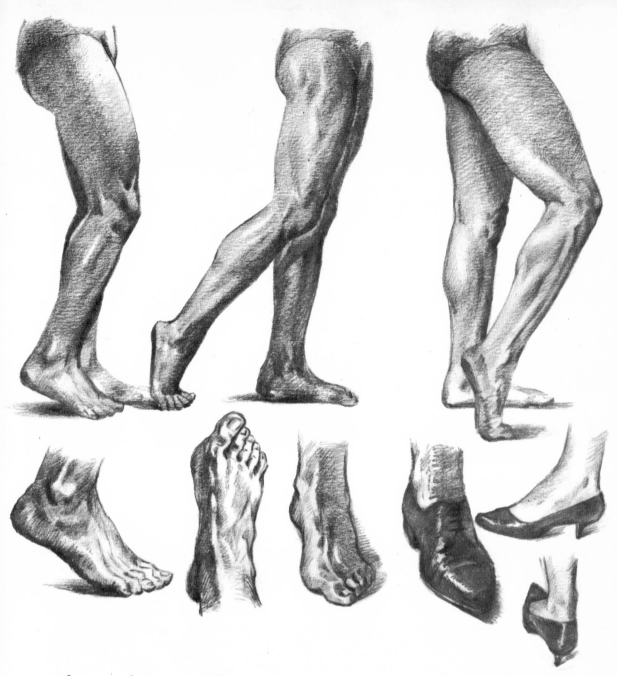

rather complex... especially if you try to draw them by eye, without bothering to box them up and construct them.

Note the shape of the man's and the woman's shoe — a shape which can be very tricky to get right if you don't know exactly what the bare foot looks like.

In the illustrations above — some of the feet are my own — you'll see that, as always, the secret lies in a careful study of dimensions and proportions and an initial accurate boxing up.

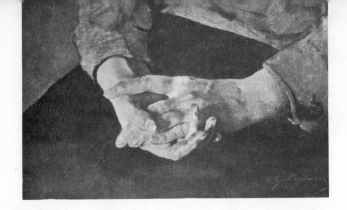

Hands,

the most complex part

of the body

81

The hand can get itself into more different positions than any other part of the body. We can see it from above, below, the front, the side; it can be clenched, open, with the fingers in various ways — an almost unlimited number of positions.

Hands can be really very tricky to draw.

If you want to draw them, you must be able to get them right. Like the head, they are usually on show — even gloves do not disguise their shape. Badly drawn hands spell death to any drawing and they frequently occur.

We'll begin our study of the hand by examining it and accepting that it can be a model in itself. Drawing hands is an entertaining occupation and, perhaps because of the difficulties, success is rewarding. Many artists have used them as the sole theme of a picture (fig. 81 above).

Let's examine the ideal dimensions of the hand (fig. 82). We find that the total length is twice the breadth — so that the palm section forms a rough square. The length of the middle finger equals half the total length (point A). The index and third finger are somewhat shorter, reaching to the base of the nail of the middle finger (point B). The little finger comes up to the last joint of the third (point C) and the tip of the thumb forms an almost perfect arc with the middle joints of the fingers.

Figure 83 illustrates the shape and dimensions of the hand in profile. Note that the view of the thumb is almost face-on (unlike the front view of the hand when the thumb is in profile). Look carefully at the length, shape and position of the fold of skin forming the inside base of the thumb (point A): this fold is very important when you come to box up this part of the hand. Compare figs. 83 & 83 a, noticing how the fold changes shape. The latter figure shows the extended thumb forming a right angle with the hand.

Study the shape of the hand when the palm is hollowed, producing wrinkles and folds of flesh. Examine all these points on your own hand (fig. 84).

The special shape and position of the nails is very important — they must be centred on their respective axes as illustrated in fig. 85.

64

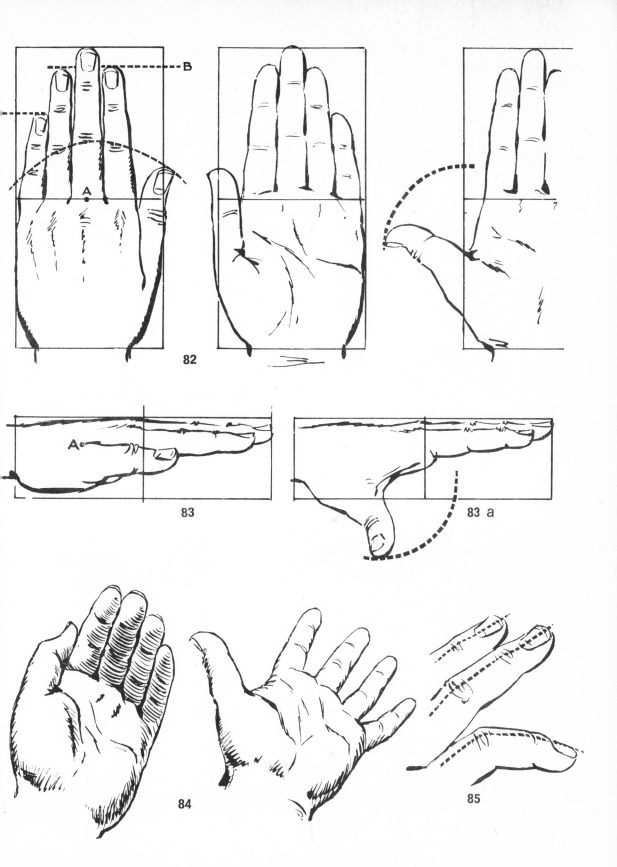

82

83

83 a

84

85

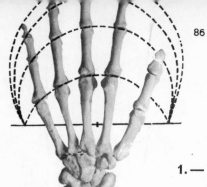

It is important to bear in mind the skeleton of the hand; this influences the external appearance to a great extent, since the bones are covered only by skin at many points (fig. 86). Remember the following two basic principles:

1. — The finger bones are simply an extension of the metacarpals.

2. — The finger joints form a series of curved parallel lines.

According to the first principle, the finger joints must always line up with the joints of the fist, no matter whether the hand is open, half-closed or clenched. Look at your own hand: open and close it. The joints always line up.

The second principle needs no explanation, merely some examples to show that this parallel relationship is maintained when the hand is half-closed, clenched or in any other position (fig. 87).

Try it for yourself, remembering, above all, to keep a constant watch on the dimensions and proportions. They hold the key to the success of your drawing. Using your right hand, draw your left in various positions; use a mirror to produce more positions.

Finally, when it comes to the modelling stage, notice how I achieved effect by encircling and blending the cylindrical shapes with extra lines and how I created volume by using lumpy shapes and reflected light (fig. 88).

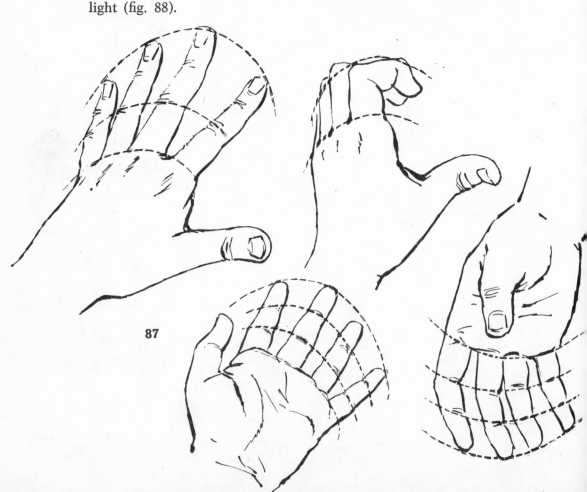

87

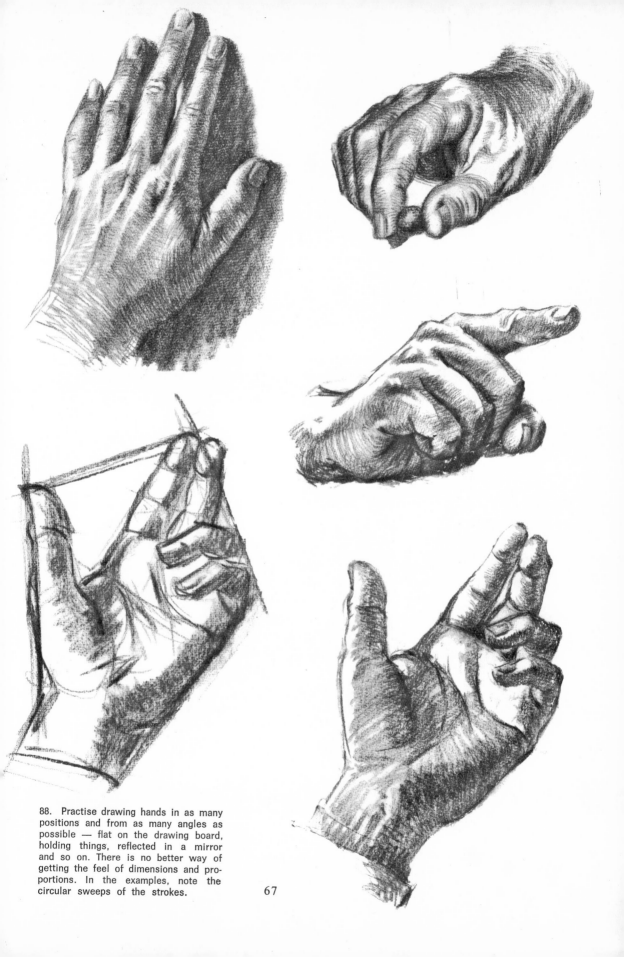

88. Practise drawing hands in as many positions and from as many angles as possible — flat on the drawing board, holding things, reflected in a mirror and so on. There is no better way of getting the feel of dimensions and proportions. In the examples, note the circular sweeps of the strokes.

67

CLOTHES

That's all on the nude figure, where the main theme was the construction, modelling and fixing of proportions of the human body, thoroughly studying its anatomy, movements and limbs. Our next problem — the clothed figure — is another matter altogether, but it is not difficult if you have grasped the previous sections.

Learning to draw a clothed figure is absolutely essential for any artist, whether drawing from a model or from memory. In either case, you will have to deal with clothing, with all the difficulties of texture, folds, wrinkles, the way it adapts to the body and so on. For instance, when an artist is working on a portrait, he may see some wrinkles on the model's sleeve at one sitting which are not there at the next — so he has to use his memory and his knowledge of draping in order to reproduce them. Even more common is the problem faced by the commercial artist or illustrator who often has to invent the folds and wrinkles in the clothes of his subjects.

This difficulty can be overcome by taking the nude body as a guide and bearing in mind a few rules and tricks which follow:

STUDYING CLOTHES AND FABRICS

We'll look at different fabrics arranged in different ways — on a table, a chair or hung on a wall, for example.

The first problems is that of volume and modelling: an age-old problem which has fascinated all the great painters. It is important to study the appearance or texture of the various fabrics you draw, faithfully reproducing that appearance, so that simply by looking at your drawing it will be possible to tell whether the fabric is cotton, thick wool or shimmering silk. This study will give you valuable experience in shaping and reproducing folds and wrinkles which you can then apply when drawing a clothed figure.

Prepare a chair or table to put the fabric on and choose the best lighting. Remember the following rules:

— *Choose bright fabrics on which the interplay of light and shade is most obvious.*
— *Work by artificial light if possible and in any case with frontal lighting to bring out the maximum relief.*
— *As far as possible, choose different types of fabric such as the following:*

 a) *A cotton sheet.*
 b) *A thick woollen blanket.*
 c) *A piece of shimmering satin or silk.*

(If you haven't got a piece of satin or silk, a woman's dress will do just as well.)

— Try to use fabrics which have been ironed, to prevent unnecessary wrinkles.

— Use different media for these exercises. For instance, draw one of the fabrics with lead pencil, one with red chalk, another with charcoal.

Look at figs. 89 & 90 below where I have drawn a sheet and a blanket using lead pencil for the first and charcoal for the second.

You should find this exercise extremely interesting. Boxing up is no easier or more difficult than for any other subject: you must know how to see the main box — the most marked folds on which the basic boxing-up lines can be based. The modelling obliges you to allow once more for the bulges and the reflected light, since contrasts and handling determine the final texture. But above all, this exercise requires a thorough study of the characteristic shapes of wrinkles and folds in general. You must see, for example, how a fold is broken off when the fabric no longer hangs vertically or when another shape appears and sometimes forms other wrinkles, sometimes changes the nature of the fold. This, in turn, will depend on what fabric you are using.

Draw your pieces of material on a rather large scale, using full sheets of paper and black crayon for best effect. Fill in the areas rapidly, darkening them, bringing out the white spaces or highlights, 'painting' them, you could say. It is fascinating and provides valuable experience.

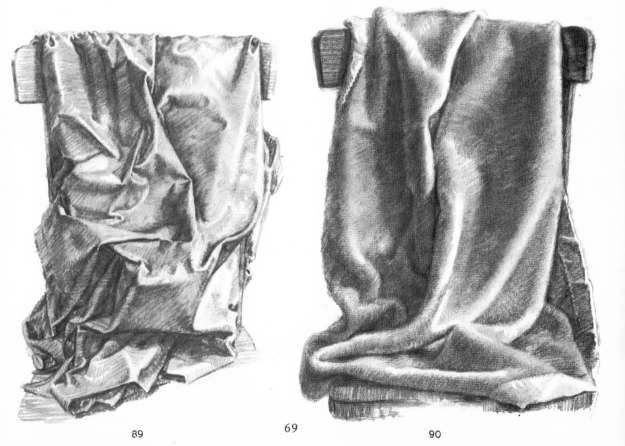

89

90

THE CLOTHED FIGURE

The clothes are your model now... with the figure underneath. You know the form of the human figure — its proportions and the length and diameter of an arm, for instance, in relation to the length and diameter of the leg or torso. But can you say that you are equally familiar with a man's suit or a woman's dress? Do you remember the exact shape, dimensions and proportions of a lapel, the position of the buttons on a mackinstosh, the cut of a shirt collar, the length and position of the belt fastenings on a pair of trousers?

Don't worry, you don't have to learn all about tailoring. But, as I said, the clothes are your model now and I should like to repeat Delacroix's maxim:

'Know the model before you draw it.'

Lawson, the American artist, has said: 'Before drawing a stool you must test its weight by lifting it, examine it closely as if you were going to make an exact replica.' Remember Leonardo da Vinci who poked about and studied the entrails of corpses in order to learn more about the form of living bodies? This also applies when it comes to drawing clothing. But, in addition, you not only need to have the knowledge, but you have to keep it up to date by documenting it, as it were, to ensure that you are drawing modern clothes and styles.

Practice means more than anything else here. Draw as much and as often as you can, so that you have a record of such things as the proportions of a man's suit and the basic styles of women's dresses. And when you have to draw a clothed figure from memory and you can't recall the exact details of the clothing, then you can either refer to your sketches or look in a magazine — at the advertisements, for instance. But don't invent — that can be disastrous.

FOLDS AND WRINKLES IN CLOTHING

We need to know the folds and wrinkles that garments are likely to assume: the shape they take on the sleeve, when the arm is bent, on the trousers or in the lap when the waist is twisted or the legs bent, and so on.

The causes can be summarized as follows:

91

a) TYPE OF FABRIC. A thin fabric wrinkles more than a thick one. For instance, notice how creased a shirt sleeve becomes. A heavy fabric, like those used for overcoats, remains more rigid and produces only a few thick folds. Compare figs. 91 and 92.

b) BODY SHAPE AND THE CUT OF THE CLOTHES. However well they fit, clothes are bound to form natural wrinkles and folds in keeping with the shape of the body. We must remember that, particularly in the case of women's clothes, the cut or shape of the garment can produce intentional fold, such as the gathers on a blouse or a full skirt.

92

c) BODY MOVEMENTS. These are the most direct cause. Obviously, when the body moves — when we raise an arm or leg, sit or bend down — a series of folds and wrinkles occur owing to the way the clothes adapt to the movement of each limb.

Now that we know these causes, we must try to simplify the effect by attempting to find a typical formation of folds, in other words a system which we can apply to most — if not all — the parts of the clothes at which wrinkles or folds occur. We've already said that the last of the above three factors is the most important. Admittedly, the body can move in an almost unlimited number of ways but, if we study it carefully, we can reduce them for our own purposes to a few simple, basic movements:

a) raising the arm or leg;
b) bending the arm or leg;
c) bending at the waist.

We'll analyse the effects produced on the clothes by each of these movements, but first, let's have a look at the general outline of a series of folds or wrinkles.

SIMPLIFYING A SET OF FOLDS AND WRINKLES

Let's take as an example the creases formed in a sleeve when the arm is bent. If we see 'what the model says to us' we may feel it's too difficult to memorise all these variable sets of small and large wrinkles, some of them more accentuated than others (fig. 93). But we can try to interpret them by getting an impression of the basic lines, the wrinkles which really reflect the movement of the arm. Look at fig. 94 and see how the mass of lines in the early drawing has been reduced to a few, simple lines whcih are still expressive enough to put over shape of the arm in this position. From here you can add as many other wrinkles or folds as you like. But, first of all, you should be able to see the simplified version without unnecessary detail. The important thing is to capture the, nature and causes of the wrinkles, remembering...

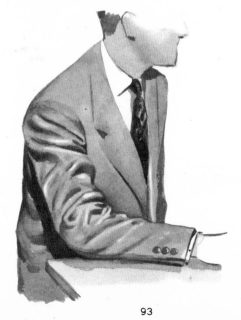

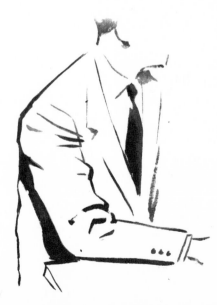

93 94

CAUSE AND EFFECT

When the arm is bent, the sleeve fabric wrinkles at the elbow and the fabric round the arm is pulled so that the sleeve is forced into transversal folds. In the same way, the cuff gets slanted as it is pulled back towards the elbow (fig. 95). The same thing happens to the trouser leg when the leg is bent.

When the arm or leg is stretched, the fabric is pulled so that it forms transversal folds in the direction opposite to the movement (fig. 96). This figure also shows how the coat is pulled out of shape when the arm is raised, so that one lapel is higher than the other and, if the coat is buttoned up, a large fold appears at the waist. All this is caused by the upward pull of the sleeve when the arm is raised.

Finally, when you bend at the waist, the fabric is pulled at the shoulder and becomes loose in front, forming horizontal folds at the waist and transversal folds at the sides and above and below the waist, meeting at the button on the waistline. The same thing happens with a woman's blouse and skirt (fig. 97).

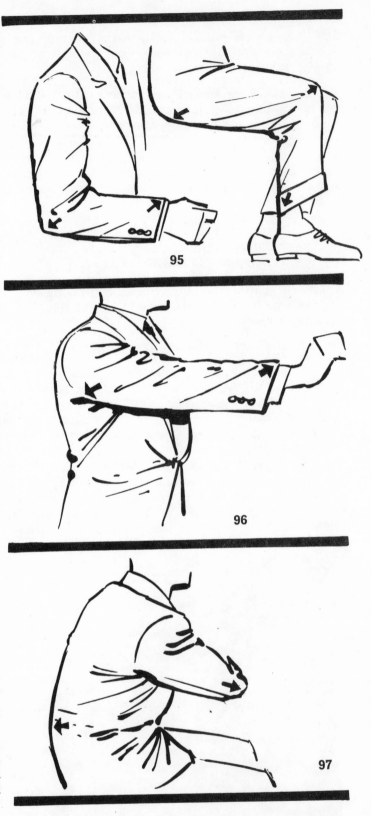

95

96

97

Cause and effect always go together and it is not difficult to discov
er the cause for every set of wrinkles. An analysis of this cause and
effect will solve most of the problem.

Always try to see the relationship between the fabric on the one hand and the body and its movements on the other: ask yourself from where the fabric is being pulled and drawn. In the area opposite that point you will always find a series of wrinkles. Stretching towards these from the point in question will be other wrinkles which will converge on the main wrinkles area.

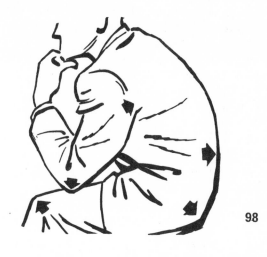

98

You can solve your problem simply by transforming the set of
wrinkles into a simplified figure as shown in figs. 93 & 94.

THE TRICK OF DRESSING THE MODEL YOURSELF

The whole question of movement and tension of fabric — and also
the proportions of the clothes, is sometimes simplified by taking the
nude figure as a basis. This is an old trick, used by many professional
artists when drawing figures from memory. Simply sketch in the naked
figure with a few soft lines and then draw the clothes over it. This
makes it easier to understand how folds and wrinkles are formed in the
garments (fig. 98).

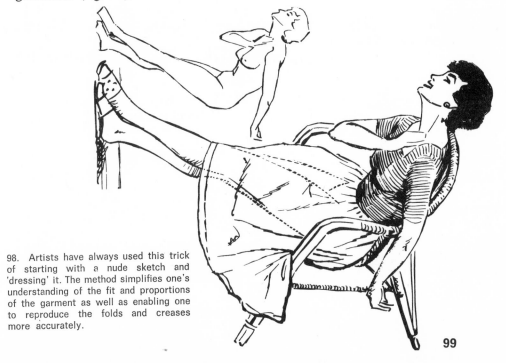

98. Artists have always used this trick
of starting with a nude sketch and
'dressing' it. The method simplifies one's
understanding of the fit and proportions
of the garment as well as enabling one
to reproduce the folds and creases
more accurately.

99

SUCCESS IS NOT A MATTER OF LUCK

Your success with figure drawing from memory or from life depends on your will to study and persevere with it. It's not a question of that frequently used and rather meaningless phrase 'being a born artist'.

The luck is in having — as all famous men have had — the will and the determination to work and learn.

... ...

In a New York park, two old men were discussing the way fate had treated them. One thought he'd been dogged by bad luck. The other admitted that he'd wasted his time and energy. As they were chatting, who should come round the corner but the multi-millionaire Henry Ford.

'See'? said one old man to the other. 'There's luck for you. From the day he was born, everything's gone right for him.'

'True enough', replied his friend, 'Everything's gone right for him. *He was lucky enough to apply himself to his work sixteen hours a day for thirty years.*'

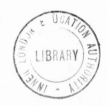